BOSTON CURIOSITIES

BOSTON CURIOSITIES

A HISTORY OF BEANTOWN BARONS, MOLASSES MAYHEM, POLEMIC PATRIOTS AND THE FLUFF IN BETWEEN

TED CLARKE

Charleston · London

THE History PRESS

Published by The History Press
Charleston, SC 29403
www.historypress.net

Cover design and internal illustrations by Marshall Hudson.

First published 2008

Manufactured in the United States

ISBN 978.1.59629.580.3

Library of Congress Cataloging-in-Publication Data
Clarke, Theodore G.
 Boston curiosities : a history of beantown barons, molasses mayhem, polemic patriots and the fluff in between / Ted Clarke.
 p. cm.
 ISBN 978-1-59629-580-3
 1. Boston (Mass.)--History--Anecdotes. 2. Boston (Mass.)--Biography--Anecdotes. 3. Boston (Mass.)--Buildings, structures, etc.--Anecdotes. 4. Cookery--Massachusetts--Boston. 5. Historic buildings--Massachusetts--Boston. I. Title.
 F73.36.C53 2008
 974.4'61--dc22

 2008032145

CONTENTS

CONTENTS

INTRODUCTION

Boston is a favorite city for travelers and most of the people who live there love it—for a reason. Boston is rich in tradition and lore. But there are more stories to tell about Boston and the towns around it. Here you'll find short, fascinating accounts of little-known events told briefly and briskly. To illustrate the interconnectedness of these tales, consider the following information.

Edgar Allan Poe lived and worked in Boston, although he never spoke kindly of the city or of its other writers. Poe, however, begins an interesting link of Boston people and stories. It is claimed that Edgar Allan Poe's macabre tale "The Fall of the House of Usher" is based upon actual events that took place on the site of Lewis Wharf in the eighteenth century. Two lovers—a sailor and the young wife of an elderly man—were trapped in their trysting place, a mysterious underground tunnel, by the avenging husband. Years later, when the old Usher house was torn down in 1800, two embracing skeletons were found at the foot of some steps behind a rusty iron gate.

Lewis Wharf had been Hancock's Wharf, named for its owner, Thomas Hancock, uncle of John. Before that it had been Clark's Wharf. William Clark was a wealthy merchant and city councilor. He owned many ships and he, or at least his wharf, seems to connect us through time to the story of the young lovers. Clark's Wharf was also the location of the first house owned by Paul Revere. Revere later moved to North Square, putting him opposite the mansion of the same William Clark, one of the finest houses in Boston during the 1700s. The three-story brick mansion and its proud gardens later were owned by Sir Charles Henry Frankland, a wealthy descendant of Oliver Cromwell.

King George II gave Frankland the choice of becoming royal governor of Massachusetts or customs collector and he chose the latter, as it produced better income. The staircase in the main hall of the Clark/Frankland House was so wide that Frankland used to ride his pony up and down the stairs to the second and third floors. But odd as that seems, the story of Frankland that follows is even stranger. Sir Charles "stars" in the story of "The Baronet and the Barmaid," but you'll have to dig under some rubble to find him.

Connections between people and events in the compact Boston area tend sometimes to trip over one another. You're likely to find them as you read. The chapters in this book have been arranged so that some of this serendipity may more easily happen.

These unique selections will make fun and fast reading for those riding or waiting for their plane, train or bus, or for the New Englander happy to find more intriguing stories about his or her favorite city. Boston travel books are common. This book is uncommon, and it's not just for travelers. Many chapters fit the subject heading of "curiosities"; some don't.

The names of some of the people will resonate, but this book takes a different look at them. Most of the stories have not been widely written about. Some are totally off the radar, even for historians. No other book covers what this one does. You'd need an extensive library of esoteric sources and a wide scope of Internet to gather these. It took a historian with a love of Boston to put this together.

The text has been divided into logical sections, but the reader can skip around or read from cover to cover. *Boston Curiosities* will make a medley of memorable moments.

UNSUNG BUT FASCINATING BOSTONIANS

BOSTON'S JOHNNY APPLESEED

When settlers first came to Massachusetts from England nearly four hundred years ago, they found themselves in a mostly barren, sometimes hostile territory where they would have to depend mostly on their own inner strengths and ingenuity to survive. At times they must have felt quite alone. But one man seemed to like it that way.

Reverend William Blackstone was not the first English settler in the New World. He was in elementary school when John Smith stepped ashore in Jamestown. He had finished college, earned a master's degree and become a minister by the time the Pilgrims had held the first Thanksgiving. In June 1623, Blackstone was one of two ministers onboard the ship of Captain Robert Gorges en route to America to propagate the gospel in a church settlement. They reached Wessagusset (later Weymouth) and moved into the nearly deserted settlement in the middle of September.

Gorges's plans went awry and he and many of the others returned to England. Blackstone (or "Blaxton," as he is sometimes called) left Wessagusset, but not Massachusetts Bay. He moved, by himself, to Shawmut peninsula in what is now Boston and lived there as the only non-Indian on what would become Beacon Hill, overlooking the mouth of the Charles River.

If Blackstone had been thinking about real estate futures, he chose well. The hill was higher in those days and he chose the protected south side, which still had great views. Location, location, location! His home was where Louisburg Square would be built and

where notables like John Kerry would squat in more recent times. Blackstone was without nobby neighbors, but not without material possessions. He was a lot better off and much more prepared than many settlers in early Massachusetts.

Blackstone was a virtual Robinson Crusoe. He brought to America nearly two hundred books in several languages and had the largest library on these shores for some time to come. He also brought foodstuffs and saved apple cores from the ship and planted them so that soon he had a fully flowering orchard downhill on what would become America's first public park, the Boston Common. He probably also "inherited" many of the possessions of Gorges and his followers when they returned to England, including a bull on which he rode around.

By the time the Puritans arrived in Boston in 1630 on the huge *Arabella* and two other vessels, Blackstone was living comfortably in a house he had built and probably munching on fruit like Johnny Appleseed. The Puritans, led by Governor Winthrop, chose Charlestown as their dwelling place, but that wasn't wise. Many of them soon fell sick and died from bad drinking water.

From his lofty hillside perch, Blackstone beheld their calamity and, Christian that he was, offered to help. He had enjoyed his peace and solitude and relative bounty for several years and must have known that inviting these strangers to cross the river and share his good drinking water would lower property values from his point of view, but he felt sympathetic or duty bound and bade them to come on down.

Winthrop jumped at the chance. He and hundreds of others crossed into Shawmut and, for the next four years, Blackstone's life as a hermit was over. Curiously, one of the Puritans had been a college classmate of Blackstone's back in England—Reverend Johnson. It was his wife, the Lady Arabella, for whom the ship had been named, not curiously, because Reverend Johnson was the chief financial backer of the project.

The Puritans stayed and Shawmut was renamed "Boston." Three years later, land becoming scarce, Governor Winthrop and the leadership "granted" Blackstone fifty acres of the seven hundred he had previously owned, and the next year Blackstone sold them

forty-four of the fifty. They used the land as the Common and grazed their cattle on it. Blackstone, who had left England to escape the tyranny of the lord bishops, would now leave Boston to escape the tyranny of the lord brethren.

In the spring of 1635, Reverend Blackstone turned his back on Boston and headed for Rhode Island with his small herd of cattle loaded up with all his possessions (including his library). In what was then Rehoboth, but is now Cumberland, he built another house and planted another orchard with a type of apple called yellow sweetings. There he lived until his death in 1675. Still skilled in real estate, he selected another site on a hill high above a river that would become the Blackstone.

He wasn't the only minister fleeing to Rhode Island. Another was Roger Williams, who was kicked out of Salem and founded Providence six miles south of Blackstone's hill. The two men met and found that they often disagreed on religion, but agreed on freedom of religion. Blackstone often rode his bull to Providence

to preach, appealing especially to younger listeners. Still a Johnny Appleseed, he gave them the first apples they'd ever seen.

He also rode his bull all the way to Boston on occasion. On one trip, at age sixty, he sold the remaining six acres of his Beacon Hill holdings at a tidy profit. Four years later in Boston, in his ministerial capacity, he met a poor widow, Sarah Stevenson, who had six children. Having lived all those years as a bachelor, Blackstone, an out-of-the-box thinker, decided to try marriage and acquire a quick family to help him cope with old age. They were married by the governor in Boston and the next year had their only child, John. William was sixty-five years old.

They lived in Rhode Island. Sarah died there in 1673, William two years later at age eighty, just prior to the start of King Philip's War, which would affect his original town of Weymouth, thus bringing the story full circle.

BULLY FOR BULFINCH

On July 4, 1817, James Monroe, president of the United States, visited Boston for a week. His host was the chairman of selectmen, Charles Bulfinch, who held a position similar to that of a mayor. Bulfinch and the president got to know one another quite well during a week in which they were constantly together.

But it almost didn't happen that way. At the annual town meeting two years earlier, Bulfinch was not reelected to the board of selectmen. When the results of balloting were announced, many people stormed out of the hall in loud protest. Four weeks later, the town meeting was held and all nine selectmen resigned to protest Bulfinch's being turned out.

Bulfinch's defeat had been the subject of discussion all over Boston in the time between the two meetings. He had educated himself in England and became the first American architect. For decades he had worked tirelessly and contributed greatly to the city at great cost to himself, designing a Boston that was the envy of other cities.

At the new election, the largest attendance ever recorded in Faneuil Hall voted for a new slate of selectmen. Bulfinch was easily

returned to office and was asked to speak. His speech was about the need to enforce laws and how doing that had turned people against him. Those who listened appreciated the man who had done so much for their town and received so little in return. They voted unanimously to have the speech published in all of Boston's newspapers.

Despite having designed so many of Boston's finest buildings, and serving on the city's board of selectmen for all those years, it wasn't the only time Bulfinch had been mistreated. He earned no salary for his service and had been in debt more than once, landing in jail because of bankruptcy.

When President Monroe rode with Charles Bulfinch along the streets of the city, he admired some of the outstanding architecture. Each time he asked who had designed a building, Bulfinch was able to say that it was his own handiwork. Monroe was so impressed that he offered him the position of architect to the capitol in Washington, D.C., at twice his current pay.

His job would be to complete the wings of the capitol building and construct the central portion and dome according to designs that had already been made. He took the job, left Boston and followed

the plans, except for a row of columns in front, which Bulfinch borrowed from his own design for the Massachusetts State House.

The devotion, good taste and experience that had allowed Bulfinch to make Boston the most beautiful city in America were now put to work for the whole nation. After forty years of planning and indecision, the nation's capital was completed under the supervision of the decisive Bulfinch.

He returned to Boston after twelve years, living there until his death in 1844. He had never lost his love for Boston. After an architectural tour of Europe, he had returned in 1786 to a city that lagged behind others in style and improvement. When he left it for D.C., Boston was the most perfect architectural city in the country. The town could not possibly thank or pay him adequately. His labors were their own rewards.

ABIGAIL ADAMS, ABLE ADVISOR

Abigail Smith Adams is unique in several ways. For one thing, she is one of only two women to be the wife of a president and mother of another. She had more impact than most women of her era, particularly as a trailblazer for forthright women who followed her early example.

Her father, William Smith of Charlestown, was the son of a wealthy Boston merchant and a Harvard graduate who was the son and grandson of Harvard graduates. Reverend Smith was minister of the First Church in Weymouth. Abigail's mother, Elizabeth Quincy Smith, also was descended from prominent and wealthy New Englanders, these from Wollaston, now in Quincy.

Abigail did not go to school, but her father had one of the best libraries in the Boston area. He encouraged his daughter to use it and she did. She also met and spoke with her parents' visitors, who were often well read and opinionated, and Abigail came to be the same way.

Her ability to take a stand on an issue and argue with the young lawyer John Adams made her stand out from the rather colorless young ladies he was used to. This led to friendship and that led to

love and marriage. The young couple set up a home in Braintree (now Quincy) and she soon became pregnant.

Abigail learned to manage the household and its expenses while John, an itinerant lawyer at that point, was often away for weeks and months at a time. She hadn't thought of marriage as a series of long separations from her husband, but this was only the beginning.

She learned to cope with her situation. When, a few years later, they moved to Brattle Square in Boston—where Government Center is now—she learned to love the hustle bustle and could socialize with the most influential families in the Bay State, read four newspapers a day and keep up with current events—which were dramatic indeed with the events leading up to the Revolution.

It got to be more exciting than she liked, however, and the Adamses moved back to the farm. But John was a man who got caught up in politics and was elected a delegate to the Continental Congress. Now he had to go to Philadelphia, leaving the farm and household in her hands. She made the farm and household run smoothly and economically and even made a few investments in his absence.

Fortunately for them and for us, Abigail had learned to write letters during her early teen years. But her notes were special. They were her means, as an intellectual, self-educated woman, of expressing her ideas and opinions. Though she wrote to friends, family and acquaintances, it was the correspondence between husband and wife that shaped their relationship. The letters became a channel of greater intimacy between her and her spouse.

Just as using e-mail is less intimidating for some than talking on the telephone, for these two strictly disciplined spouses, letter writing seems to have allowed a more open means of expression than speaking face to face. And their long absences from one another made it necessary. Abigail said so: "My pen is always freer than my tongue. I have wrote many things to you that I suppose I never could have talk'd."

The letters show a woman of intelligent thinking and strong opinions. John's replies show the resonance of her ideas and tell us that she did have an influence, and that may be where she made her greatest contribution to posterity.

Abigail believed that a man and woman shared the task of making a life; that each had responsibilities for making a marriage work. To her that meant that women ought to be educated as well as men and that they should share legal rights as well. She often wrote to John about the necessity to educate girls and women. Once she wrote: "You need not be told how much female education is neglected, nor how fashionable it has been to ridicule Female learning," and, "If we mean to have Heroes, Statesmen, and philosophers, we should have learned women." (John Adams said he agreed with her.)

Abigail was breaking new ground here. She was a leader among women for speaking out for the rights of women—indeed, she was a leader among women just for speaking out. She also defended John against a host of critics and soothed his wounded feelings. During his first months as president, as he waited for her to join him in Philadelphia, he asked her to hurry: "I never wanted your Advice and assistance more in my life"; and, "The Times are critical and dangerous, and I must have you here to assist me."

In 1800, they moved into the newly built White House as its first occupants. Though Abigail liked the house from an architectural point of view, she found it cold and drafty. There wasn't enough firewood, most rooms were unfinished, there weren't enough lamps and the stairways weren't ready. Ever the manager, she used the East Room to hang her washing. That unlikely use has become part of folklore.

During the time that John had been assigned to Paris, Abigail had formed a friendship with Thomas Jefferson and his younger daughter. But when Jefferson became vice president in the Adams administration, she came to view him as a traitor, and the friendship of Adams and Jefferson was lost for many years. After both had retired from the White House, it was Abigail who (without John's knowledge) got the two men to correspond once more. Their correspondence lasted until the day they both died, July 4, 1826.

By that time, Abigail was gone. She had seen their son Charles die due to alcoholism and their daughter Nabby die of cancer, and she was pleased with the career of John Quincy, though she did not live to see him become president. Abigail died of typhus.

She influenced both her husband and her son, as well as future generations of women.

The Baronet and the Barmaid

Two stories from the Boston area in 1755 run parallel to one another and intersect with an earthquake. One concerns a very rich man; the other, a very poor girl.

The wealthy man was William Browne of Salem. Twelve years before the earthquake, he built a mansion in the town of Danvers, north of Boston and next door to Marblehead. The poor girl was from Marblehead. Her name was Agnes Surriage, the daughter of a Marblehead fisherman. In 1742, Agnes was sixteen years old and worked at the Fountain Inn as a waitress. Though she was poor, she had a great smile and a cheerful personality. Agnes made others smile.

Agnes was scrubbing the inn floor when Sir Henry Frankland, collector of customs for the port of Boston, came in. The handsome twenty-six-year-old baronet fell immediately in love with the young girl. Legend says that he gave her money to buy a pair of shoes, as she had none. Later he went to her parents and persuaded them to make him their daughter's guardian. They agreed, and he sent Agnes to school in Boston. When she got older, he wanted to marry her, but his family (who lived in England) would have disinherited him since she was low class. So she lived with him, but they did not marry.

By this time William Browne and his wife Mary Burnet were entertaining lavishly at their Danvers estate. Browne had bought the first private carriage in town, and his summer estate was immense. Built in the shape of a huge letter "H," its two wings were eighty feet long. In the ceiling of its pretentious hall was a large dome. On one wall hung a beautiful tapestry made by a Dutch artist.

Henry Frankland also built a huge manor house in Hopkinton. To get to it you had to drive your carriage through an avenue of chestnut trees. Then you would see his formal gardens and orchards. Inside the house, the great hall was hung with rich tapestries. Frankland,

who worked for the British government, was recalled to England. There, for the first time, Agnes met her lover's family. And for the second time, they rejected her. From there, Frankland decided to tour Europe, and he spent a good amount of time in Lisbon.

Now mother nature took control of the lives of these two, the rich man and the poor girl from the Massachusetts Bay Colony. On the morning of November 1, 1755, Frankland set off in his carriage with a female passenger for the city while Agnes stayed behind at their villa. A little later, without warning, a devastating earthquake struck the city. Lisbon was almost completely leveled. Many who survived the quake were drowned by the tidal wave that followed.

Agnes was saved because the section where the British expatriates lived was built on higher, more solid ground. She knew the route Frankland had taken and searched for him until she heard his cries for help from beneath the rubble. She clawed away at the debris until her fingers bled. Then she coaxed and shamed others into helping her until her lover and their friend were rescued from entombment, alive but not well.

Eighteen days later, a quake hit Boston and eastern New England. The ground undulated in sickening wavelike motions for four and a half minutes, followed by lesser tremors for the next four days. While chimneys were toppled and windowpanes were broken in Danvers, Browne's fine estate suffered most. Built on a hill, it was broken into three sections. The quake also shook Browne's determination to live there ever again. Local people called the place "Browne's Folly" and believed that the Lord had punished him for being such a spendthrift. To their Puritan minds, building such a house was wickedness.

Things never improved for Browne. The next year, two of his children died of disease. In 1761, his second wife passed away. On April 27, 1763, he died of apoplexy in a field he owned in Beverly. The monument he ordered for his tomb was never erected. His grand Danvers folly was moved to the base of the hill and then carted away to three locations.

Agnes fared better. She nursed Frankland slowly back to health. Once he recovered sufficiently, the first thing Frankland did was marry Agnes. And when they returned to England, his family

gratefully accepted the girl from Marblehead as Lady Agnes Frankland. Agnes went from barmaid to baroness—truly an earth-shattering event.

INTERESTING BOSTONIANS

Nathaniel Hawthorne was born in Salem, just north of Boston, and worked in the customhouse on the waterfront both there and in Boston. He married Sophia Peabody, who lived on Beacon Hill in Boston and who started the first kindergarten in America. They moved to Concord. Hawthorne was a famous writer whose books are still read today. The best-loved were written about Salem. He wrote *The Scarlet Letter* and *The House of the Seven Gables*. The latter is about a real house next to the one in which he was born. The home has secret passages and you can visit it today.

Bishop Cheverus was the first Catholic bishop of Boston. He started the first cathedral when there weren't many Catholics and he had to ask for donations from Protestants. Bishop Cheverus was so popular that many of the wealthiest and best-known Bostonians (including President John Adams) gave him money.

Ben Franklin was born in Boston across the street from the Old South Meetinghouse just north of Downtown Crossing. He went to Boston Latin School—the first public school in America—and later worked as a printer for his brother. Sometimes Ben wrote articles for the newspaper his brother published, but he knew he couldn't sign them or his brother wouldn't print them. So he called himself "Silence Dogood" and he slipped the articles under the door of the print shop late at night. His brother thought they were fabulous and printed them. When he found out later that Ben had written them, he was furious. Ben ran away to Philadelphia, so everyone forgets he was born here.

Henry Knox also learned to be a printer. But in the days before the American Revolution, Knox worked in a Boston bookstore.

Many of the books had to be ordered from England, and many of the British (Redcoat) officers ordered military books that were about cannon and artillery. When the books arrived, Knox eagerly unpacked them and read them before he gave them to the officers. He read them so well that he became General Washington's artillery officer. It was Knox who brought cannon hundreds of miles from Lake Ticonderoga to Boston, where they were used to drive the British out. During the Revolution, he became a general and when Washington became president, Knox served as the first secretary of war. And all from a little reading and thinking.

James Michael Curley has two statues in Boston not far from Faneuil Hall. He served as mayor of Boston many times and as governor of Massachusetts. Curley knew how to connect with people. He was a great speaker. Even his enemies said that he could "charm the birds out of the trees." When he was younger, he was put in jail for taking a civil service test for someone else. But even while he was in jail, the people elected him to public office.

The success of the smallpox vaccine can be traced to Zabdiel Boylston, a Boston doctor who first used the vaccine on his son and a servant. Fearful mobs stormed his house and a bomb was thrown through his window. People couldn't understand why a doctor would *give* someone a light case of a disease in order to inoculate them against a worse case. In 1721, smallpox swept through Boston, killing 1 out of every 6 people. By then, Dr. Boylston had vaccinated 286 people and 280 of them survived the epidemic. After that, people believed.

The Saturday Club's members were famous authors who lived in Boston in the middle of the nineteenth century. They met at the Parker House at the corner of Boylston and School Streets (now the Omni Parker House) on Saturday afternoons. Among them were Henry Wadsworth Longfellow, Oliver Wendell Holmes, James Russell Lowell, Ralph Waldo Emerson, John Greenleaf Whittier, Amos Bronson Alcott and Nathaniel Hawthorne. They were joined at times by Mark Twain and Charles Dickens, who

came to America to give lectures. These people were the rock stars of their age.

Joseph Warren was the leader of the Sons of Liberty, which opposed the British, especially during their occupation of Boston. The group included Paul Revere and Sam Adams. It was Dr. Warren who told Revere to make his ride on the night of April 18, 1775, to warn minutemen that the regulars were on their way to Concord, a ride for which Henry Wadsworth Longfellow made Revere famous.

Warren also led the Americans in the Battle of Bunker Hill and was killed during the struggle. The British buried his body, but the Americans dug it up again and brought it to Paul Revere (who had been his dentist). Revere was able to state that an examination of his teeth proved that this was definitely Joseph Warren, and he was reburied in a Boston cemetery. Warren's son, John Warren, began Harvard Medical School, and his son, John Collins Warren, was the first to use ether to put a patient to sleep during an operation. This operation was done at Massachusetts General Hospital, where Harvard Medical was originally located.

T.W. LAWSON: TRULY A TOWERING FIGURE

Thomas W. Lawson, sometimes called the "Copper King," was a millionaire who lived much of his life on his fabled country estate, Dreamwold, in Scituate, Massachusetts. He was also a skilled yachtsman who had a special boat named for him that was made by Thomas Watson (of telephone fame) at the Fore River Shipyard in Quincy. Named the *T.W. Lawson*, the boat was the first and only seven-masted schooner ever built. At the time (1901–02), it was the biggest project the huge shipyard had ever handled.

The boat would be 403 feet long and equipped with twenty-five different sails that could be affixed to its seven masts. Together they could spread 43,000 square feet of canvas. The masts themselves were steel on the lower parts and pine on top and bore traditional though complex names, but Lawson just called them Sunday, Monday, Tuesday, Wednesday, Thursday, Friday and Saturday.

Another strange thing about the vessel was that it was to be driven entirely by the wind at a time when steam power was coming into its own. It would be used to haul freight, and the space saved by using sail instead of steam would allow for a capacious hold.

The schooner was launched at Quincy on July 10, 1902, after being christened by Helen Watson, daughter of Thomas A. Watson. As the heavy vessel went down the ways, some feared its weight might carry it right across Fore River. Tugboats were readied to intercept it, but were not needed. Still, the *T.W. Lawson* was not an easy craft to maneuver. It was very hard to turn about and its deep draft made it difficult to sail in coastal waters. It began to run aground or list and soon gained a reputation as an unlucky boat. The company found it hard to properly staff it. Some thought it a homely vessel, with its seven masts making it look like "a picket fence."

The *Lawson* was first used for coastal freight, primarily to haul coal. When the price of coal went down, it was decided the ship could carry light fuel oil to Europe. It was nearing England on December 13, 1907, when it foundered on rocks in the Scilly Islands off the southwest Channel coast during a ferocious gale. Only two of its crew survived.

A Scituate resident, Tom Hall, spent years researching the vessel both here and in England, even diving on the wreck and interviewing relatives of those who were involved in rescue efforts. He has written an excellent book entitled *The T.W. Lawson*. The ship's namesake is known less for his strange schooner than for Lawson Tower, which he built as a complement to his country estate, Dreamwold. He had another side, too, as we'll see.

Born in Charlestown, Lawson quickly became known as bold, even reckless. Before he was old enough to finish high school, he had earned and then lost $60,000. By age twenty-one he had earned his first million, and early in the twentieth century he was reportedly worth $60 million. In today's dollars that made him one of the wealthiest men alive. Though he had little formal education, Lawson was self-taught, unusually expressive and steeped in literary tradition. In fact, he would become a famous writer.

As the century turned, however, Lawson was a highly successful stockbroker who had an office at 333 State Street in Boston

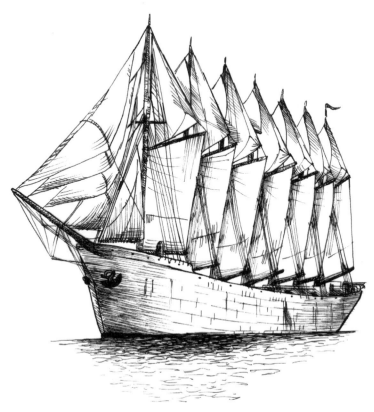

overlooking the harbor, and from its windows he dreamed panoramic dreams. A large, mustachioed man, well turned out in expensive three-piece suits and parting his hair in the middle, Lawson was also superstitious. He believed that the numeral "3" was lucky for him and also believed that his huge pocket watch brought him good luck.

Lawson enjoyed artwork and nature in equal parts, and his office and home both appeared crammed to crowding with each. Closer examination, however, would have yielded the understanding that here was a logical man with a sense of harmony, and that each picture, sculpture and flower fit nicely into sequence with the others. He even paid $30,000 to have a carnation named for his wife. It was called the Lawson Pink.

A financier, he went into partnership with Standard Oil in an attempt to corner the market on copper. The enterprise eventually failed and Lawson took some of the heat from stockholders, but became known as the "Copper King."

A fervent yachtsman, he visited locations south of Boston. He and his wife Jeannie spent some time in Cohasset and, traveling about from there, visited Scituate, where Jeannie fell in love with the ocean views. Lawson would do anything for her, and he immediately bought land and built a huge country estate facing the ocean that he named Dreamwold. A "wold" is a high, undeveloped plain and he developed this part of North Scituate or "Egypt" according to his vision—thus Dreamwold. He spared no expense but built it simply. An article in *House Beautiful* called it "simple living, richly but restfully expressed."

Dreamwold, a stock farm, became the most famous in the country, boasting a mile-long racetrack, thoroughbred horses, show dogs, a blacksmith shop and even a fire station. It also had telephones between its many buildings when few people had them at all. It had underground cable for electricity, and the whole expansive place was surrounded by a white, Kentucky-style fence, much of which still stands. The buildings faced the ocean, and at one time were open to the public. Lawson built a small bungalow called the Nest for Jeannie and him to use when things got too busy. When a post office was needed, he built one for the town just outside his gates. To get to Boston he built his own railroad spur and each morning rode his own train for a forty-minute non-traffic commute.

One of his thoroughbreds, Boralona, won all of its races except one. It lost the Kentucky Derby on a day when Lawson wasn't carrying his lucky watch. He gave all the horse's winnings to charity. He must have had his watch when he and his family and friends visited Monte Carlo, however. Lawson had such a winning streak that the casino had to close down because the bank ran out of money. So, if the story is true, then Lawson was indeed "The Man Who Broke the Bank at Monte Carlo."

At the beginning of the twentieth century, the Scituate Water Company built a steel standpipe to tap a water source, and Jeannie, looking out one of Dreamwold's back windows, hated what this

commercial intruder had done to her pristine view. Lawson, ever sympathetic to Jeannie's desires and unable to have it removed, decided to cover it up and got permission to do that.

He didn't just paint it sky blue or disguise it as a tree. That would not have been in keeping with Lawson's grand vision of things. No. He hired an architect to travel to Europe and research the best design to cover up the standpipe. His architect came back with a design patterned after a tower in Germany that was part of a castle overlooking the Rhine.

The tower that was built, Lawson Tower, is still considered by many to be the most beautiful water tower in the world. It is certainly the most photographed and the most expensive. It was completed in 1902 when a ten-bell chime and a clock were added.

The tower has a widow's walk at the top that was used by Lawson to look out over the Atlantic, where he could watch his copper ships with their copper ore passing Scituate on their way to Boston. Sailors, of course, could also use the tower as a landmark and, fittingly, Lawson Tower was listed as an American Water Landmark in 1974. Two years later it made the National Register of Historic Places as an individual property.

Lawson also had a flagpole made from the tallest tree ever to leave Oregon. In transshipping it, the conveyance it was on broke through wooden planking on the Fore River Bridge, but they got it to Dreamwold, where Lawson raised huge flags on it.

In the early years of the twenty-first century, changes were made to his vaunted tower. The standpipe began to leak and was shortened so that it is now only ten feet tall. The tower was reshingled and restored. Renovation costs were paid for from mitigation funds paid to the town by the railroad in funding for historic preservation. The bells were repaired using Community Preservation funds. The town now owns the tower and tank, but it is administered by the Scituate Historical Society.

A book for children has also been written: *The Legend of Lawson's Elephants: An Elephantasy*, by Robert Louis Sheehan. It's a blend of historical fact and fancy. Lawson kept many elephant mementoes and carvings at Dreamwold. The superstitious owner believed that they were good luck. He also paid for an elephant fountain on the

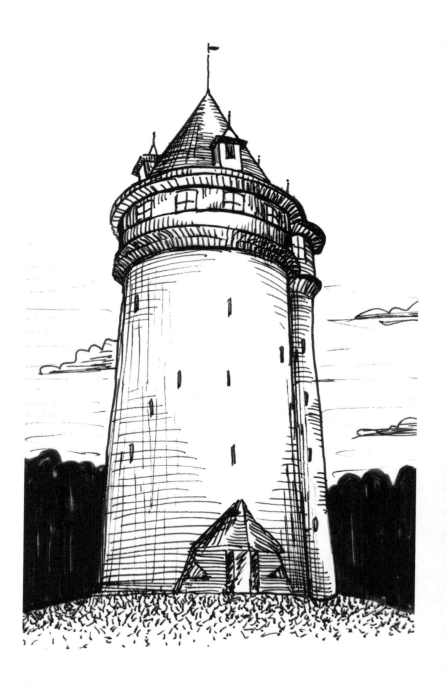

town green, Lawson Common, on land he donated. Of course, the number of elephants was three. At Dreamwold, Lawson had three thousand elephants carved of ivory, jade, bronze and wood. Lawson was fiercely loyal to all of his workers and asked nothing from Scituate while frequently making gifts. The elephants and the donations gave Lawson a softer look. From his business practices and his writings an image of a tougher, sometimes even ruthless person emerges.

One of the best books about Lawson is *Beauty, Strength, Speed* by Carol Miles and John Galluzzo, chairman of the Scituate Historical Society. The book has marvelous descriptions and photos of Dreamwold.

Perhaps his most lasting writing flowed from his interest in yachting. He built a scow, *Independence*, and attempted to enter it into the America's Cup trials but was not allowed to. Run by the New York Yacht Club, those races have certain rules and Lawson seems to have flaunted them. He would not join the club or cooperate with it. In any case, his boat was probably not competitive. But they wouldn't let him try and that set off his storied temper.

Partly in retaliation, he wrote *The Lawson History of the America's Cup*, which many yachtsmen have proclaimed simply as *The Book*. Its three thousand copies were sought after and became collector's items. Twenty years ago, another fifteen hundred were printed and these also draw a good price. But one chapter recounts Lawson's view of his own experiences with the club and gives his highly negative personal views of some of the club members.

As a financier, he outmaneuvered the famous Standard Oil Company for control of a Massachusetts energy company. After that he joined forces with the company in promoting Amalgamated Copper, the name under which Standard Oil reorganized the great Anaconda mine. As a broker, Lawson could simply tell clients "Buy Amalgamated" and they would do it. He and Standard drove up the price of stock and then drove it down again and picked up the shares for pennies on the dollar, much of it from people who couldn't afford the loss. One report said that thirty people committed suicide as a result.

Lawson wrote a serialized book, *Frenzied Finance*, in which he placed the blame on John D. Rockefeller, who really had no involvement

in it at all. When the story first appeared in *Everyone's Magazine*, the first issue sold out in a few days and future issues were so compelling that the magazine's circulation rose to number one in the country. Not only did it give an insider's exposé of Wall Street's cutthroat practices, but it also said enough about the insurance industry to provoke an investigation.

In 1906, Lawson wrote a novel, *Friday, the Thirteenth*, which ten years later became the (first) movie with that name. The lead character is clearly based on Lawson. In it he tries to justify creating a panic in the market so that its ethical problems will be exposed and then solved. The book helped sink the market and the man.

Ironically, the boat named for him would also sink on Friday the thirteenth. Curiously, Lawson's title may have made the date a symbol of bad luck. A book called *13* by Nathaniel Lachenmeyer says that the day and the date were first brought together by Lawson.

Lawson gradually lost his wealth and began to spend his time in Oregon, where most of his relatives moved. In 1922, Dreamwold was auctioned off to pay for back taxes. Some of the buildings were moved, but the major section became a restaurant and then a function hall. In 1983, it was sold to developers for condominiums, which now stand on the site, but first the town had a big send-off party for all the locals.

When Jeannie died in 1906, Lawson was heartbroken and couldn't function for a long time. He also had to testify before a Congressional hearing about insider trading and didn't do well. After that he lost his influence and gradually lost most of his money. Lawson died, nearly broke, in 1925. His tower remains as a fitting monument to a man who rose to great heights at the turn of the twentieth century.

Some historic characters are towers of strength. Others build towers or monuments, which seem to recall their stature. But looking up won't tell you everything. For some stories you have to dig down.

FEELING THOSE GOOD VIBRATIONS

Alexander Graham Bell would become famous for inventing the telephone. However, he invented other things and spent much of his life as a teacher of deaf children. His mother had been deaf since childhood and her three boys communicated with her by using sign language. Alec Bell, a gifted pianist, played the piano for her and she could "hear" it by putting the tube of her hearing aid up against the piano's sounding board. His father was a professor of speech who helped people with problems such as stammering. He was eager for all his boys to become good students, but Alec did poorly in the Royal Edinburgh High School, where he had to study Latin and Greek. He didn't like the studies and after four years he left school without a diploma.

At that time, Alec's grandmother had just passed away and Alec's father sent him to London to live with his grandfather for a while and to learn better discipline. His grandfather thought Alec would do better away from his father and brothers and might develop his own personality. So the fifteen-year-old Alec took a train from Edinburgh, Scotland, where his family lived, to London.

His grandfather was strict and insisted that his grandson dress like a gentleman and study hard. He was also a speech expert and taught Alec many of the things he had discovered. But he was different from Alec's father. He was able to get Alec interested in things so that he *wanted* to learn. In that way, his grandfather was a much better teacher than Alec's father or his schoolteachers had been. Alec respected his grandfather and they got along well with each other.

The summer after Alec moved in with his grandfather, Alec's father traveled to London to meet an inventor he had heard about. He picked up Alec on the way and took him with him. His father couldn't believe how different his son had become. He had grown from a clumsy, messy schoolboy into a well-dressed and confident young man.

After a year, Alec went back to Edinburgh to rejoin his family. But his father began treating him like a little boy again. Alec became restless and depressed and considered running off to sea. At the last minute, he changed his mind and decided to become a teacher instead. He got a job at a boarding school teaching speech, and in a year was promoted to assistant master and got a job in a better school and then a college.

When he was not teaching, he studied phonetics. He would spend hours experimenting with his voice, touching his throat and face while making different sounds so he could feel the vibrations. When his grandfather died, Alec's father took over his work in London and invented an alphabet called "visible speech." The signs in this alphabet stood for sounds, not letters. Each symbol represented the positions of the mouth, tongue, lips and throat used to make a particular sound.

Sometimes his father would take Alec with him when he taught college students. Alec would wait outside the classroom while his father asked students to give him words that were difficult to say, or even foreign words. His father would write the symbols from the visible alphabet on the chalkboard as he heard the words. Then he would call Alec in. Alec would read the symbols from the blackboard and be able to say the foreign words even though he'd never heard them before.

Eventually, Alec's family moved to Canada, but Alec got a job in Boston teaching deaf-mutes. He taught students who couldn't speak or hear how to make sounds by using their mouths, tongues and teeth in the correct ways. He was so good at it that he was in great demand and his classes were very large.

At the same time, his interest in sounds led him to try to improve the design of the electric telegraph. Telegraphs could only send one message at a time, and he wanted to change that. His work took him to the scientific lab of Charles Williams in Boston, where he met a young electrician named Thomas Watson who became his assistant.

Bell was in a race with other inventors to improve the telegraph. During his work on it, he developed a theory for how he could transmit a human voice over a wire. He and Watson worked on this

until they made it work, and on February 14, 1876, he applied for a patent, just two hours ahead of a rival. A few weeks later he was awarded the patent. It became one of the most valuable patents in history. However, he had to defend it in court over six hundred times. Questions remain about his obtaining the patent, but he certainly invented the first viable phone.

The major improvements to Bell's telephone actually came from Watson and from Thomas Edison, who made the sound much better. Ironically, it was Bell who worked on Edison's scratchy-sounding phonograph and developed it so that it made clear recordings. That phonograph was the grandfather of today's CDs and iPods, but if you ask today's children what a phonograph was, they may be unable to say.

In some ways, Bell was far ahead of his time. He developed something called the photophone, which sent messages on light rays. It only worked on sunny days and at short distances, and it had to wait more than one hundred years for the invention of fiber optics. Then came the cell phone.

Bell also designed kites, airplanes and a hydrofoil boat. He developed better ways to breed sheep. And he and his father-in-law co-founded the National Geographic Society. However, to this day, Alec Bell's name is almost always associated with the telephone.

Thomas Watson Always Had a Call Waiting

Thomas Watson is best known as co-inventor of the telephone. The first telephone message went from Alexander Graham Bell to Thomas Watson. Bell called, "Mr. Watson, come here, I want you," on March 10, 1876, in Boston, and Watson will always be remembered for that moment.

It was Watson who made Bell's ideas work, but he never became really famous for it. Even when he was in school, he didn't want to show off. He was smart in school, but he kept it a secret. Watson kept going from one thing to another. As soon as he lost interest in one thing, he was off doing something else. He always followed his calling, and with Watson, there was always another call waiting.

He was born north of Boston, in Salem, where his father owned a stable and rented horses. Watson was born in a house in the yard of the stable. As a boy and a young man, he tried lots of things before he found something he liked. He got a job in Charles Williams's machine shop in Boston, where he learned that he could change dreams into a reality. That's what he did for Alexander Graham Bell.

Watson became the star worker at the machine shop. When Bell came to them with a difficult problem, Watson got the job. Bell was a professor at Boston University working with the hearing impaired, and the invention he was working on was called the "harmonic telegraph." It was supposed to be able to carry six or eight messages to a distant location. It never did work, but it brought the two men together.

Bell had the ideas and Watson was a genius at making things. Together they made a great team. But they didn't start out to invent the telephone. While they were working on a new kind of transmitter, they used a wire submerged in sulfuric acid in a metal cup and some acid spilled onto Bell's clothes, at which point he called for help. Watson heard him through the receiving end of the telephone, and history was made.

Watson worked on the telephone for six more years and built all of the early telephones. He got 10 percent of the income from Bell's patents, including the first one, which is considered the most valuable patent of all time—ever—anywhere. Watson got rich. But once the major work had been done, he lost interest.

He wanted to do something else. He wanted to do some of the things he had always dreamed of doing. First he took a trip to Europe and then he came back, got married and bought a farm south of Boston on the Fore River in Braintree. At that time, it was nothing but trees, water and meadows. He loved it there. You can visit it today—there's a Thomas Watson Museum and Library there—but the view isn't so good.

Watson was a terrible farmer, so he quit. He and a friend opened an engine company. One of the things they made were engines for boats. Then when war broke out and the navy wanted someone to build new torpedo boats. Watson's Fore River Engine Company went into the shipbuilding business.

In a little while, bigger ships were needed and Watson's Braintree shipyard wasn't big enough. So he bought land downriver in Quincy and began the Fore River Shipyard, the largest in the United States. Watson floated his machine shop downriver and then he had his four-story office building put on barges and floated down the river *while people were still working at their desks!*

By that time he had children who had reached school age. He had become interested in kindergartens, and was disappointed to learn that there weren't any. So he set up one on his own land at his own expense. The town liked it so much it started its own and Braintree was the first place in New England to have kindergartens. Schools, of course, needed lighting, and Watson was instrumental in creating the Braintree Electric Light Department.

After a few years, the shipyard had money problems and Watson left. He asked himself, "What *else* have I really wanted to do?" Well, he'd always been interested in rock formations, so he and his wife went to Massachusetts Institute of Technology and earned degrees in geology. He even had a fossil named after him, and he went to California to look for gold mines.

At age fifty-six, Watson went to England and became an actor, touring with a group that put on stage plays. Within months he was doing speaking roles in Shakespeare's hometown. He eventually quit that to join other actors in forming their own company. He even wrote new plays based on books so the actors would have something new to perform.

But he never stayed long at anything. Back in Boston by 1912, Watson spent his last years doing theater, dramatic readings and lectures on geology and on the telephone. In 1915, he was sent to San Francisco to answer the telephone. It was the first phone call made across the whole country, and Alexander Bell was in New York talking to him.

Watson and his wife traveled all over the world, sometimes for years at a time. He continued exploring life at the age of seventy-seven when he took up painting. He died in 1934 at his winter home in Florida. He had written in his will that he wanted to be buried in North Weymouth overlooking the Fore River basin that he liked so much. His grave is at the top of the hill and it does overlook the river. We don't get to choose where we are born, but Thomas Watson did what he wanted as often as possible. He wanted and got Weymouth as his final resting place.

THE TWISTING THREADS OF HISTORY

We often think of people on history's pages as individuals with their own "stories," so it can be surprising and interesting when we come across them visiting one another in those stories. You'll find several people you know about in this short tale.

The author of *A Christmas Carol, Oliver Twist* and *David Copperfield* was popular on both sides of the ocean. When Charles Dickens visited America in 1842, he was as popular as today's top movie stars, though far more literary. His books had sold well in America, so he decided to come here, give speeches, take notes and write about what he saw.

Dickens didn't bargain for the whirlwind schedule of appearances that a modern-day author like David McCullough

would take as a matter of course, and he wasn't pleased with it. However, he had some things to see for his own edification while he was in Boston. He wanted to visit Laura Bridgman, whom he found at the Perkins School for the blind in South Boston. Laura was deaf as well as blind and had been since age two, but she had accomplished great things.

Just as Laura would become unique, Perkins Institute had already reached that level. Founded by Samuel Gridley Howe, it had been bankrolled by the Boston philanthropist Thomas Handasyd Perkins, who had donated his home (in today's Post Office Square) to the rapidly growing school.

The institute quickly outgrew the house, and Perkins funded the establishment of a new one near City Point in South Boston. Dr. Howe heard about Laura and saw her condition as a challenge he wanted to take on. In 1837, people believed that the best you could do with someone like Laura was to feed them. They couldn't possibly be educated. But that was precisely what Howe wanted to do, and he brought her to South Boston for that purpose.

Howe's work with Laura began the process of helping the handicapped and disabled. It also created a big news story and several pages for Dickens's forthcoming book. Howe used a hand alphabet to teach Laura how to read, write and do math. He taught her how to communicate with others and to make known her wishes. She later came to understand Christianity and the Bible and even wrote letters opposing slavery.

Howe had another innovation at the Perkins School, and it was one that helped to bring Charles Dickens to its gates. He had established a printing department where students would produce embossed books. He hoped to get famous authors to let the school emboss their books. As you may have guessed, Dickens heard about it and used the school to print, emboss and distribute 250 copies of his latest book, *The Old Curiosity Shop*.

Laura became the first deaf-blind American child to learn the English language and she did it fifty years before the better-known Helen Keller. In fact, Helen learned her skills because of Laura. Helen's mother learned about Laura from reading

that book that Charles Dickens was writing about his American adventures. He called it *American Notes*. His account gave hope to the Kellers and they went to a medical specialist in Baltimore, who confirmed that Helen would never see or hear again, but that she could be taught.

He recommended an expert to her. The expert was Alexander Graham Bell. Bell told the Kellers to write to the Perkins Institute and ask them to find a teacher for Helen. The director sent Anne Sullivan to Alabama, where Helen lived. Anne was a former pupil at Perkins and was visually impaired herself, though not blind. She took with her a doll that Laura Bridgman had made for Helen Keller. Anne taught Helen using the same hand alphabet that Gridley Howe had used with Laura. In time, Helen was able to read and write, and even to speak.

At first, Helen became known as "The Second Laura Bridgman," but Helen progressed well beyond what Laura had achieved, mainly because she had Anne Sullivan, who devoted her life to Helen. Their story is well told in numerous books and in the film The Miracle Worker. Helen was truly stubborn and strong-willed, but so was Anne. Helen was also extremely intelligent, and once she understood that letters stood for words and words for things and ideas, she learned quickly. Helen went on to become a world-famous speaker and author.

Helen Keller met every U.S. president from Grover Cleveland to Lyndon B. Johnson and was friends with many famous figures, including Alexander Graham Bell, Charlie Chaplin and Mark Twain. Twain declared that the two most interesting characters of his century were Napoleon and Helen Keller.

The Perkins School continued to grow, getting so big that by 1912 it moved just west of Boston to a thirty-eight-acre site on the Charles River in Watertown, where it still stands. Laura Bridgman and Helen Keller stand as models of what can be achieved against overwhelming odds. Gridley Howe and Anne Sullivan showed what dedicated teachers can do.

BOSTON'S MERCHANT PRINCE

The "prince" in the title of this story had feet of clay, but he played a major role in the story of the Bunker Hill Monument and in the Laura Bridgman tale.

Do you recall the George Bailey character played by Jimmy Stewart in the film *It's a Wonderful Life*? Like Bailey, if this man had not lived, we'd have to tear pages out of our history books, because he's the one who got things done. But unlike the Jimmy Stewart character, T.H.P., as he called himself, didn't always do things that would make an angel ring a bell. As a character who appears on many pages of the history books, he was in and out of the lives of people we know about, many of them famous. So we must keep his pages of text, though some are sort of sordid.

Thomas Handasyd Perkins, or T.H.P., was born in Boston in 1764. When he was just a lad, he stood on a cobblestone page of history beneath the balcony of the Old State House at the head of State Street in Boston, part of a jubilant crowd listening to the reading of the Declaration of Independence, which had just been signed. That must have made him feel involved, and he kept doing things that made him part of Massachusetts history. (John Quincy Adams stood there, too, though they may not have been aware of one another. Perkins was three years older than J.Q.A.)

When he reached his twenty-first birthday, T.H.P. inherited a small amount of money and soon thereafter went into partnership with his brother James, who then ran a business on the Caribbean island of Santo Domingo (Haiti today). The climate of the West Indies didn't agree with Thomas, so he became the Boston-based partner. You might have thought the business would have been disagreeable, too. The commodity they were dealing was slaves. T.H.P. was in the slave trade.

T.H.P. traveled widely, and in 1785 he sailed to China. The year he arrived at the port of Canton was the same year the Chinese opened it to foreign companies. When the gates opened, there was T.H.P., like a Red Sox fan camping overnight when playoff tickets

are in the offing. His timing was always impeccable, and he was one of the first Boston merchants to take advantage of this new opportunity. He would shortly fine-tune it until it hummed with profits.

His ship was loaded with ginseng, but the Chinese had plenty of that. He noticed, though, that they were eager to get furs, which another American ship had brought from America's Pacific Coast. On his next trip he would be bearing furs. T.H.P. was good at knowing what would sell, but didn't trouble his mind about what he *should* sell. In the early part of the Chinese trade days, T.H.P.'s ships would sail from Boston to the Pacific Northwest, where they would take on those pelts and skins, cross the Pacific and trade those furs for Chinese goods. These included tea, silks and porcelains. Later he would bring the Chinese something else.

Timing was big here, too, because the Santo Domingo slave business was about to come to an end. In 1791, revolution struck that island and James Perkins barely escaped with his life. It was all right, though. The Perkins brothers had the revolution business covered. You've probably read about the French Revolution, when all those heads rolled. T.H.P. was not a bystander reading about it. He played a role. And he kept his head.

The Perkins firm began to sell food in revolutionary France at high prices to people who couldn't get it any other way. They also picked up the trade between France and the West Indies. Their ships flew the flag of a neutral nation, which let them get by ships from warring nations like the British—most of the time.

Trading in France was risky, with Madame Guillotine lopping off heads left and right. T.H.P. and his brother often traveled along with their cargoes to make sure they got paid, so he was often in Paris during the Revolution. He met lots of interesting people such as future President James Monroe and the pamphleteer of the American Revolution, Thomas Paine. He liked both, but his diaries show that he found Paine to be sloppy, fond of drink and sometimes opinionated and stubborn.

Perkins conspired with Monroe to smuggle the son of the Marquis de Lafayette (who is in our Bunker Hill story) to America and out of harm's way. He smuggled a lot of people when

Napoleon came to power, learning how to use bribes to get guards to look the other way.

Bribes were small stuff, though. They had already used those in China. The Perkins firm had a whole fleet of ships built, and they opened a branch office right in Canton. That put them at the front of the line among foreign traders. They could easily buy things when the price was right or when their competitors weren't around. The move to China came right in time, too.

In the years from 1807 to 1812, when America was having trouble with both England and France on the sea, President Jefferson got Congress to pass an embargo on all foreign trade. That was bad news for most trading houses, but the Perkinses trimmed sail and tacked smartly. They sold everything but the rafters in their Boston warehouses, bought whatever they could in China at barrel-bottom prices and then waited out the squall.

When the War of 1812 ended, they were positioned to make a handsome profit by keeping their heads and checking the wind. T.H.P. wrote to his brother, "Now is the heyday of life, let us improve it, and when the inclination and ability for exertion is over, let us have it in our power to retire from the bustle of the world and enjoy the fruits of our labour."

Some of that fruit, though, would come from forbidden trees. The West Coast soon ran out of easily procured furs and the Perkinses needed something else to trade with the Chinese for all that tea and other desirable goods. Opium sounded like a good answer. Up until 1815, the British East India Company had controlled that illegal trade, smuggling it into China from India. But the Perkinses were ready for an end around.

During the American Revolution, some members of the Perkins family who were Loyalists left America for England or parts of the British Empire. There they bided their time like sleeper cells. One relative had become a British trade merchant in Turkey. That was a place where opium grew, and when the British relinquished control of that trade, he had positioned the Perkinses to buy large quantities.

T.H.P. knew, of course, that the opium trade was illegal, but the family had also learned how to avoid being caught, or at least prosecuted. They also knew that many people considered it immoral to sap the spirit of the Chinese with the stultifying drug. They did what people still do; they rationalized it, saying that becoming addicted to opium wasn't as bad as getting drunk all the time.

In addition to this non sequitur, they said that, after all, it was the Chinese who were doing this to themselves and anyway the people who were actually bringing it in were Chinese too. (Things change but people's excuses change very little.) They might also have said (and probably did) that families all over the world were getting rich on the opium trade. You'd recognize some of the names, like Bush and Roosevelt, but one of them was Perkins. T.H.P. went so far as to oppose American help for Greek patriots when they rebelled against their Turkish overlords because he didn't want to endanger the supply of opium. Profit seems to have served as the guiding light.

Like some of the "robber barons" later in the nineteenth century, the Perkinses and others spent much of their ill-gotten fortunes on munificent mitigations. T.H.P. did do other things besides contribute to the bad habits of people on the other side of the world. He was a member of the Federalist Party, along with John Adams and George Washington. He stood for election and served many terms in the Massachusetts Senate. He served in the militia and became a colonel. He also owned large parts of the textile mills in Massachusetts and an iron mine in Vermont.

When his brother James died in 1822, T.H.P. left the business to younger members of the family and took on other projects. We will read in an upcoming section about his involvement in building the Bunker Hill Monument. He served on the committee that built it and also started the Granite Railway, which brought the stone to Charlestown and began the great days of Quincy's granite industry. He also made a tidy profit for himself.

We also read about the school for the blind for which he was largely responsible and that helped people like Laura Bridgman and Helen Keller. He offered his home to the school for the blind, and when that became too crowded, found them a hotel in South Boston, which he partially funded. What became known as the Perkins Institute for the Blind now towers above the Charles River in Watertown. T.H.P. was also a friend of Alexander Graham Bell (who was helpful to Helen), and he bought large chunks of stock that started AT&T.

He made other contributions, too, to the Boston Athenaeum, Massachusetts General Hospital, McLean Hospital and the Museum of Fine Arts. His good works got him an invitation to Mount Vernon, where President Washington hosted him.

Perkins kept mum about all that opium stuff, and he was well respected in Boston. He became sort of an *éminence grise*. People went to him for advice on almost anything. He was sort of an earlier version of the Godfather. Younger men found him helpful in getting them started in business and in giving sage counsel.

In his later years, Colonel Perkins set to work improving his Brookline estate with trees, shrubs and statuary outside, and furnishing the home with art pieces, mainly those he had brought back from

his many voyages. The home resembled an art museum. He was as shrewd with art as he was in business, and he bought the work of many famous artists. He and his family entertained and were painted by famous portraitist Gilbert Stuart. He also knew several presidents and entertained people like Daniel Webster and J.J. Audubon.

When he died at home in January 1854, T.H.P. had just turned eighty-nine. The funeral was held at Federal Street Church in Boston, where William Ellery Channing had once been his minister. The governor adjourned the state legislature so that he and the members could attend. In a eulogy, the Honorable Robert C. Winthrop called T.H.P. "one of the noblest specimens of humanity to which our city has ever given birth." Thomas Handasyd Perkins was buried in Mount Auburn Cemetery in Cambridge.

The drug trade had begun long before he was born and continues now and into the future. Slavery has ended in the West Indies and the United States, but has recently been in the news in Africa. Perkins's role in those evils is largely unknown or forgotten, at least here on earth. His name remains on the Perkins School and in many books on Boston.

In *Julius Caesar*, Shakespeare wrote, "The evil men do lives after them. The good is oft interred with their bones." Clearly, Shakespeare never met Thomas Handasyd Perkins.

JOSHUA BATES: BOSTON AND BARINGS BANKER

Joshua was born in Weymouth, twelve miles south of Boston, in 1788. His father was a colonel in General Washington's army during the American Revolution. When Joshua finished his schooling at age fifteen, he went to work for William Gray and Son of Boston, the largest shipowners in America. They were active in international trade, including the China trade, which had recently opened and by that time was thriving.

Bates was a whiz at business and soon gained a reputation that belied his years. When Mr. Gray (or later his son) had a difficult problem to solve or delicate negotiations to handle, they handed it

over to Joshua and he did a first-rate job of settling matters. He was so good, in fact, that he wanted a greater challenge. At age twenty-one, he went into business with a partner, but the War of 1812, which damaged Boston commerce, also ruined their briefly held business. He was welcomed back by the Grays, who knew a good thing when they saw it. They sent him to Europe as their agent (or "factor," as we would say today).

This job threw him in with the movers and shakers of business on the international scene, and he learned how to move and shake. Bates got to know the heads of the great commercial houses, especially the Hopes and Barings in England, and continued as the Grays' representative for many years after the War of 1812 ended. He wasn't through with that war, as we'll see later.

These business types were no fools. They recognized Bates's skills. In 1826, he formed a partnership with John Baring in London, and within two years, both were received into the firm of Baring Brothers, one of the top banks in the world. Joshua Bates eventually became the senior partner. He married the daughter of Samuel Sturgis, whose family was involved in the Chinese opium trade and whose nephew also rose to head the bank.

The Sturgis family was related by marriage to the Perkins family of Salem and Boston. Thomas Handasyd Perkins (later a noted philanthropist and founder of the Perkins School for the Blind) was one of the first in Salem to trade with China. His business was handled by Joshua Bates through the Barings Bank in London. (You can learn more about this period at the Captain Forbes House Museum in Milton and at the Peabody Essex Museum in Salem.) While the China trade lasted, the Perkinses earned pots of money, and so did Bates.

By the early 1850s, Bates had all the money he needed. He said, "I do not any longer work for money, but having arrived at that age when it would be impossible for me to arrive at any other distinction than that of a Merchant, I feel that it *is* something to be at the head of the first commercial House of the World."

Now we return to the War of 1812. Although the war had ended about forty years earlier, a lot of claims and disputes were left over. A joint commission was formed to clear these up, and Joshua

Bates was appointed umpire between the British and American commissioners. He had to come up with solutions when the two sides could not agree. So he got to make all the tough calls, some of them requiring an understanding and complete discussion of key questions in international law. Using skills he'd learned as a young man, Bates dug into the books and found out what he didn't already know, and none of his decisions were ever questioned.

As a young man, Bates had great difficulty getting the books he needed in order to learn the things he needed to know. Boston had no public library, nor did most other cities and towns. Bates presaged today's era of the café bookstore. He spent as much time as he could get away with reading the books in Hastings, Etheridge & Bliss's bookstore, educating himself on the cheap. He knew what it meant to be hungry to learn and without books at your disposal, so when he found out, in 1852, that the City of Boston was planning to establish a free public library, he was on board at once. He wrote a letter to the mayor of Boston, offering $50,000 to help.

But it wasn't an outright gift. True to his banking background, he thought of that amount as *capital*, and had strings attached. He said that the money must be invested and that the interest on his money must be spent on the purchase of "books of permanent value and authority," and also that the city must always provide a comfortable place where at least 100 to 150 patrons could come night or day to sit and read. It must also be free to all. He must have been thinking of the young Joshua hanging out in bookstores.

The Boston City Council enthusiastically accepted, so Joshua Bates became the first major private contributor to Boston Public Library, the country's first municipally supported library.

He afterward gave thirty thousand books (undoubtedly of "permanent value and authority"). This raised the value of his contribution to $100,000. He is thus considered one of the founders of the Boston Public Library. The first library was built in 1858 downtown, just off Tremont Street, and the main reference room, opened three years later, was called Bates Hall by the trustees. When the current library building in Copley Square (designed by Charles F. McKim) was opened in 1895, the second-floor reading hall was designated Bates Hall.

Bates Hall is a majestic space that has recently been restored with a $2 million grant from the U.S. government. The reading room has a barrel vault that runs the full length of Copley Square—218 feet long, 42.5 feet wide and 50 feet high. The room is lit by fifteen arched and grilled windows, which you can view from the street. The building is a National Historic Landmark.

During the Civil War, Bates's sympathies were strongly with the Union, and besides aiding the United States government fiscal agents in various ways, he also used his influence to prevent the raising of loans for the Confederacy. He died in London on September 24, 1864.

Massachusetts Was Wide Awake When War Came

Weymouth, Massachusetts, was a hotbed of pre–Civil War activity that centered around antislavery advocates like Maria Weston Chapman and her sisters. Abolitionists and other antislavery people from Boston often gathered in Weymouth, where the climate was friendlier and the streets safer than they were in Boston. The "Liberator" himself, William Lloyd Garrison, who ran a newspaper by that name, made several speeches at the Universalist church in Weymouth. Many people were recruited to the Republican cause and favored the candidacy of Abraham Lincoln.

In those days before radio, television or the Internet, political campaigning took on a different dimension. A favorite tactic was the street demonstration conducted by campaign clubs. These events helped to arouse interest in candidates and causes, but were also used as social mixers for the young men who belonged to the clubs and young women who supported them. Elections often brought out 80 percent of enrolled voters.

A Republican group called the Wide Awakes, made up of young, unmarried men, marched in support of their candidate wearing full-length white capes and lacquered white hats. They carried six-foot-long torches fed by canisters of whale oil and sang party songs. They wanted to get out the vote and also to keep an eye on the voting places. The Democrats had groups that did this, too. You thought,

perhaps, that the torchlight parade arose in 1930s Germany, but here was an earlier American version.

Some of the Wide Awakes also formed military groups in preparation for the possibility that Southern states might secede from the Union if Lincoln were indeed elected. Curiously, the election of Lincoln, whose family migrated west from Hingham, Massachusetts, brought local fame to Governor John A. Andrew, also from Hingham. It was he who mobilized support and manpower to fight the Civil War.

Andrew, little known outside of political circles, had been born in Maine and moved to Boston to practice law, and had met and married a Hingham woman, Eliza Hersey. They raised four children in that town. Andrew had strong antislavery feelings and was one of the founders of the Free Soil Party, which morphed into the Republicans. He was elected to the legislature in 1858 and easily topped the field in the election for governor of Massachusetts in 1860.

He didn't look like a governor. He was short and wide with curly hair. He looked more like a kewpie doll than a leader. But looks can mislead, and they did in this instance. Andrew was actually a tower of strength and had great vision as well. When he took office in early January 1861, Lincoln had been elected and Southern states were getting ready to leave the Union and precipitate a civil war.

The friction between the North and the South over the question of slavery and the maintenance of the Union—which began with John Quincy Adams of Massachusetts in the Congress of 1836 and strengthened with Senator Charles Sumner of Massachusetts in the Congress of 1856—reached tension-breaking intensity in 1861. One by one, the states of the South seceded, Fort Sumter was fired upon and the Civil War began.

Andrew's vision served him well. He could see what was happening and began to get ready for it. He immediately prepared the Massachusetts militia for duty and contacted the other New England governors about allowing their citizens to serve in Massachusetts's regiments. Men from as far away as California eventually joined the units from our state.

He got legislation passed to place the militia on a war footing and raised funds to send the troops to Washington. When President

Lincoln called for troops to protect the nation's capital, those from Massachusetts were first to arrive. Between the time Governor Andrew took office and the firing on Fort Sumter three months later, he got Massachusetts troops supplied and trained. Lincoln telegraphed the governors for help on April 15, asking for two regiments. Governor Andrew ordered four regiments to muster on Boston Common the next day.

Towns responded at once. In Weymouth, a special committee was formed that recommended to the selectmen that those who volunteered be paid $125. Town meeting raised it to $150. In April, a meeting was held to raise troops and James Bates was placed in charge of the town's contingent. Bates would become an important Civil War general.

By that time, troops from other towns had already gathered at Faneuil Hall, and on April 17, 1861, were on their way south. They became the first unit in the country to reach Washington and save the capital from Confederate attack. Their trip was not easy. Two days after they left Boston, they were attacked in Baltimore by mobs, and four were killed. Governor Andrew had foreseen the trouble in Baltimore and had already chartered steamships to bypass that city in case that state had left the Union to fight on the other side—which it did not.

The Weymouth company went to Fort Warren on Georges Island in May, escorted by the town band. As part of the Massachusetts

Twelfth Regiment, it left for New York on its way to Washington. As the men paraded down Broadway, they marched to the song "John Brown's Body," which was becoming a popular war tune. They also made up verses about a different John Brown, who was a member of their regiment. A bishop who heard the song asked Julia Ward Howe of Boston to write new words and the song became "The Battle Hymn of the Republic."

Governor Andrew also worked with freed slave Frederick Douglass in forming two regiments of black soldiers, the Fifty-fourth and Fifty-fifth Massachusetts, some of whom came from Ohio and other states. After getting permission from the U.S. government, he started a regiment with Robert Shaw as colonel, but most black men in the Boston area were reluctant to join. A major problem was that they would not be allowed to serve as officers and some also feared reprisals if they were captured.

Andrew asked an advisor, George Stearns, for suggestions in filling the ranks. Stearns volunteered to recruit areas near the Canadian border. "There are a great many runaways in Canada, and those are the ones who will go back and fight." Stearns donated much of the cost of recruitment himself. He went to Buffalo, where he was so successful that he recruited enough men to complete the Fifty-fourth Regiment and almost all of the Fifty-fifth.

The governor of Ohio asked Massachusetts leaders to stop taking so many potential soldiers from his state, as he wanted to form his own regiments. The black regiments from Massachusetts were portrayed in the film *Glory* and are memorialized in a frieze across the street from the State House.

When peace came, Andrew argued for leniency toward the South, which Lincoln would have followed had he not been assassinated. In all, Massachusetts contributed 160,000 men to the Northern armies, and they came from every city and town, exceeding the state's quota. From the state treasury, Massachusetts spent $28 million on the war.

When the troops came home bearing their battle flags, they marched with bands blaring up to the State House and presented the battle-torn flags to Governor Andrew. The flags now hang in

the rotunda of the capitol, above the portrait of John A. Andrew, the great "War Governor" of Massachusetts.

GENERAL JAMES L. BATES: BORN TO BE A SOLDIER

James Lawrence Bates was born August 11, 1820. He would never quite overcome the feelings of restlessness that seemed to rise up in him every now and then like some kind of six-, seven- or seventeen-year itch. This striking out for greener pastures that seemed to be part of Bates's soul also allowed him to swim in the stir of history that was swirling around America during his prime years. America, like Bates, was on the move in the mid-1800s, and Bates touched, tasted and sampled the foam this movement generated.

Bates attended public schools for a time, but did not give much effort to his schoolwork until he was in his middle teens, when he realized he'd better learn something if he wanted to succeed in life. However, he was an early poster child for the term "late bloomer." He had a listless, lackluster start, but a grand finish, and he's a good example of why it's unwise to give up on somebody because they're slow out of the gate.

Bates became a teacher in South Weymouth, and a good one, but he didn't feel that teaching was his calling. He was popular, but he was troubled by the insatiable itch of wanderlust. His mind (and his feet) turned to boots. Bates joined a shoemaking firm that was prominent in town, but he wasn't content to work for someone else. In just over a year, he began his own shoe business with a partner, Benjamin White. No luck there, either. That only lasted a couple of years before he went back to being an employee, this time a fancy one. He became a shoe cutter, a highly skilled position in the industry, but he seemed as though he must have hated it and only did it to earn a living.

The year 1849 brought the gold rush. The news of the discovery of gold in California caught young Bates's attention. Several young men from town set off for the gold fields, including Bates. But he wasn't just a forty-niner with a pick and shovel. No sir. This was to be a business for him. He joined the Boston and California Joint

Stock Mining and Trading Company. They bought the ship *Edward Everett* and equipped it for a long voyage.

The trip to California was well chronicled. It carried Reverend Joseph Benton, who preached sermons during the voyage and later published his diary about the trip. Another passenger, William Thomas of Maine, had been lured to the sea by reading Richard Henry Dana's well-known narrative *Two Years Before the Mast*. He wrote two books on his voyages to California. Bates also kept a journal of his trip, called "Diary of an Expedition to California."

When they got to San Francisco, most of the passengers and most of the company hurried off to the gold fields. But Bates stayed with the ship. The gold mining didn't pan out, so the company sold the ship to Bates and a few others. They sailed to the tip of South America and then around Cape Horn, stopping at the Peruvian islands for a cargo of guano—fertilizer from seabirds that is rich in phosphorus and nitrates. Back in Boston the cargo and the ship were sold and James had himself a nest egg.

He went back to his old job for a short time and then used his capital to start a boot business that lasted only two and a half years. Next came a livestock company that had started up in Illinois. He went there, too, but quickly got out of the business and came home again and ran a general store for about a year. He next went to Boston, opening a new business for a few months. Then came a new leather business called Durrell, Bacon & Co., which was also located in Boston. That kept him busy until the Civil War broke out.

After the Confederates attacked Fort Sumter, President Lincoln called for volunteers and Weymouth formed Company H of the Twelfth Regiment of Massachusetts Volunteers. In those days, the soldiers elected their own captains. They chose James L. Bates.

It was nearly two years before the Twelfth saw action, but Bates trained them so thoroughly that they became one of the best regiments in the entire army. Surprisingly, he had found his niche. When he began his military career he knew nothing except that he liked it. He worked at it and found out everything he could. He just

loved being part of it. Remember how Bates had been such a great schoolteacher? Well he must have called on those skills again with his regiment. His enthusiasm and example were infectious. His men bought into the mission and their teamwork was great. The Twelfth Regiment built a reputation for drill and discipline even before they went into battle.

Bates was also cool under fire and was a skillful tactician. Within a few months, he was promoted to major and then colonel. His regiment fought at Fredericksburg, Chancellorsville and Gettysburg, where Bates was wounded in the neck but would not leave his post. In the spring of 1864, he fought alongside General Grant and was considered a tower of strength. There's a monument to the Twelfth Massachusetts Infantry and Colonel James L. Bates on Cemetery Ridge at the Gettysburg battle site.

During the war he came under fire twenty-eight times—more than anyone else. At the war's conclusion, he was made a brigadier general. He was a charter member of Reynolds Post 58, Grand Army of the Republic, and served as its commander all but one year, when he was elected commander of the Massachusetts GAR.

After his return from the war, James Bates went into the banking business with John Fogg, but as you may have guessed, that wasn't the end of the winding road for Bates. He went on to a career as a broker, working in the business district of Boston. There might have been more, but he died in 1875 on November 11, a notable date for an old soldier to pass on, since it is now Veterans Day. His many friends and all of his remaining regimental colleagues attended his funeral.

Bates was an interesting man. He loved adventure and hated the dawn-to-dusk grind. Today he might go white-water rafting or skydiving. He took the dangerous trip around South America to the gold fields, yet he spent no time panning the rivers for gold. He was among the first to sign up for the Civil War. And there he blossomed and grew and made his reputation. After the war he was mustered out. It was back to the same old habits, except for his leadership of the military groups in the GAR. That duty must have satisfied the soldiering muse.

THE WRITE STUFF: THE FIRST BALLPOINT PEN

Some things we use everyday can easily be associated with their inventors—the electric light bulb and the telephone come to mind. Yet there is real doubt about Edison and Bell being the true inventors of each those things. Other inventions are shared among several people. And some names have disappeared from sight.

The ballpoint pen was invented by someone most people have never heard of. In fact, few people ever used the pen he invented, and credit for the invention usually goes to someone else. Why? Well, it's kind of a mystery. We'll lay out the facts as we know them and perhaps you can solve it. The ballpoint pen was invented in 1888 by John Jacob Loud. Even the circumstances of his invention of the ballpoint are fogged in mystery. His ballpoint *may* have been meant to write on leather, but look at his background and you'll wonder why this man would be connected to the leather industry.

Loud, born in 1844, earned a master's degree from Harvard and studied law in a famous Boston firm. One of his bosses later became governor of Massachusetts. He used his education to draw up wills and settle estates. No sign of a ballpoint invention so far. Next he worked as an assistant to his father, who was cashier of the Union National Bank. He succeeded his father at this position and held it until 1895—by which time he had invented his pen.

Loud showed other talents as well. He spoke at the launching of the first warship built at the Fore River Shipyard in 1900,

then the nation's largest shipyard. He wrote prose, poetry and song; his words and verses were often published. Since he was such a good speaker, he was frequently asked by those organizing public events to be the featured speaker. Loud was glad to speak—without pay. But we're still groping about in the dark to find the Loud-ballpoint connection, right?

There's more. Here's a quote from *300 Years of Louds in America* that gets closer to the person himself:

> *Mr. Loud had such a dignified and courtly bearing, and fine presence, as to be conspicuous everywhere. He lived his life as an unselfish public-spirited citizen, a man of sterling and noble character, a sensitive, refined and scholarly gentleman, scrupulously honest and faithful, and conscientiously and strongly for the right.*

Perhaps he thought a public-spirited and unselfish person should not try to become rich or famous, so let's look at how others thought of him. The only quote we have is the one we've given, but Loud was elected or appointed to many important positions. He was a trustee of Derby Academy in Hingham; trustee of the local bank; trustee, clerk and treasurer of the Tufts Library; and president of the Old Home Week Association. We also have learned that he was interested in local, state and national politics, but he never ran for public office.

Then there are these, from the same book as the quote noted previously: "Mr. Loud...was always interested in...mechanical invention." And: "Mr. Loud was the inventor of the Ball Point Pen, which he patented Oct. 30, 1888. He also invented and patented Dec. 27, 1887 the Home Guard Safety Cannon for firecrackers."

Aha! Perhaps that's the connection. He *liked* to invent mechanical things. Let's look at what the patent and inventing information has to tell us:

> *We know very little about Mr. Loud, except that he may have been a leather tanner or a shoemaker. He invented a fountain pen that had a small metal ball at the tip to regulate how the ink came*

out. Such a pen would be excellent for writing on leather and fabric, as he suggested in his patent application, calling it useful "for marking on rough surfaces—such as wood, coarse wrapping paper, and other articles—where an ordinary [fountain] *pen could not be used."*

But the Loud biographers say nothing about a career in leather tanning or shoemaking, so why would a banker, a musician, a poet, a lawyer want to write on leather?

There's a saying that "necessity is the mother of invention." Usually, industrial inventions come from people inside the industry who work at it every day and notice the need. But perhaps Loud had a conversation with a tanner or a shoe manufacturer (maybe a relative) around the cracker barrel in the general store. Maybe that person wished out loud that there were some way to mark leather. Or maybe the store owner wanted to write on fabrics like those at the general store. Loud, the inventor, may have taken the challenge and come up with an answer. Or maybe you can come up with the missing link.

He only made a few of his pens, but an advertisement was designed, probably for use in newspapers. It shows diagrams of "Loud's Rolling-Pointed Fountain Marker" and mentions him as the inventor. But he didn't sell many, and the patent was allowed to lapse. Here's the patent information:

(No. 392,046). This patent described a pen having a spheroidal (ball-shaped) marking point capable of revolving in all directions which was held down by three smaller anti-friction balls, themselves held down by a flaired spring-loaded rod. A threaded cap at the end of the pen could be removed to recharge the pen with ink. The patent described the invention as being especially useful for the marking of rough surfaces such as wooden or paper boxes, coarse wrapping paper and other surfaces where the ordinary nib of a fountain pen could not be used because it would split, spatter or catch.

Up until the late 1800s, pens and ink were separate items. Pens, often made of quills or reeds, had to be dipped into an inkwell

every few minutes to replenish the supply. By the time Loud made his invention, "fountain pens" permitted people to take their pens with them.

George and Lazlo Biro of Hungary usually get credit for the first commercially successful ballpoint pen, invented in 1938. Their invention was essentially the same as Loud's. Within a few years, big companies had cornered the market on throwaway pens, while other companies produced what they called quality writing instruments.

Loud was accompanied by other instruments—often musical ones. Despite his many interests, he was known as a devoted husband, father and grandfather, a man who spent large amounts of time with his children, helping them to set and pursue intellectual and moral goals. He remains a mystery. Perhaps a reader will figure him out.

No Car, No Phone...Just Millions of Dollars

The Boston Public Library is one of the biggest and best in the world. It got that way in stages and with plenty of help. Joshua Bates, who succeeded as a stockbroker and partner in Barings of London, donated large amounts of money to help establish the Boston Public Library in its new building in Copley Square. Bates Hall, the majestic 218-foot-long reading room, is named for him. As a young man, Bates "hung out" at bookstores, reading without buying. He wanted to give others an easier time of it.

The Bates story is a little like that of John DeFerrari. DeFerrari is little known, even in Boston, mostly because that's the way he wanted it. This strange but accomplished son of an immigrant made an impact that lives well beyond his memory and affects the lives of others even today.

His story begins in 1863 in a crowded tenement among the narrow streets of Boston's North End. John was the oldest of eight children of an immigrant from the northeast coast of Italy, Giovanni DeFerrari. Giovanni came to Boston when the North End was mostly Irish. He was one of only a few Italians in the neighborhood.

But he made his way by selling fruit, successfully buying his own store and later buying up properties.

When John came along, the family was not impoverished, but his father was a stern disciplinarian who was determined that his children must make their own way. He gave John a basket of fruit and told him to leave the North End, cross Atlantic Avenue to State Street and sell the fruit to businessmen. His father made it plain that he was not to come home until he'd sold all of it. John never came home with unsold fruit, and, with thrift, was able at age thirteen to buy a horse and wagon and sell more fruit in more places. He brought home the empty basket and something else—a driving ambition.

In observing the businessmen who were purchasing his fruit, he had become somewhat envious. While some people turn envy into anger or hopelessness, John had enough confidence (probably from seeing his father succeed) that he was determined to make himself, the son of an Italian immigrant, as successful as these Yankees were.

So motivated was he, and so good did he become, that soon he bought a store in Dock Square near Faneuil Hall and that, in turn, was so successful that he eventually bought out the whole building and set up a wholesale fruit business. From there, John DeFerrari opened the Quality Fruit Store on Boylston Street opposite Boston Common, where he also sold imported delicacies. His swanky shop was near the present Colonial Theatre, and thus it was on the pedestrian route between the railroad station at Park Square and the downtown business district. Once again John prospered. Now he had reached the peak of his business. He no longer needed or wanted to expand. Instead, he used the profits from his business for investments. He bought stocks, bonds and real estate.

By bright coincidence, his store was right next to the Boston Public Library in one of its pre–Copley Square incarnations. This was to be one of those moments when happenstance morphs into history. John began to use the library and came to admire it as an institution. He read books on economics, business, law and real estate—whatever might help him to become a successful investor. DeFerrari never relied on bankers or lawyers, but preferred to educate himself about whatever was necessary.

The Boston Public Library had been the first in the country to lend books to its patrons. It didn't matter what your class or background. It offered opportunities for self-improvement. John realized that he could never have succeeded as he did without its help. Wealthy by age twenty-eight, he had sold his fruit business and spent all his time working on his investments and real estate holdings.

The Boston Public Library also made progress, moving from Boylston Street to Copley Square with the help of the Bates donations and into the bold architectural gem known as the McKim building. There nine hundred readers could sit in its reading rooms and 600,000 volumes could rest on its shelves. It ranked second only to the Library of Congress in the size of its collections. Nonetheless, by the end of World War II, that building, too, was straining at the seams.

John DeFerrari decided to fund a new wing. In 1947, the skinny, bald, ordinary-looking man of eighty-four years stood in the Trustees Room of the Boston Public Library's McKim building. He came bearing gifts, and stood beneath the portrait of trustee Josiah Benton, who had given a $1 million bequest to the library in 1917. So Bates and Benton had been benefactors, and DeFerrari furthered that line.

DeFerrari had a nodding familiarity with Benton, who frequently stopped at his fruit emporium on his way down Boylston Street. But Benton would not have remembered DeFerrari. Few people would, since he was not only nondescript, but seemed to crave anonymity. He always dressed plainly, owned no car, had no telephone, picked up his mail at general delivery, paid for everything with cash, had little to say and stuck to himself. He never smoked, never drank and never married.

When DeFerrari offered to set up a trust fund in excess of a million dollars, he stunned the trustees. He asked for little in return, but perhaps there was after all a little arm's length vanity in him. After seeing Benton's portrait, he wanted one of himself—in the new John DeFerrari wing.

The dream of a wing turned into the reality of an addition equal in size to the McKim Building, but totally different in design. This was designed by famed architect Philip Johnson. It stands today on

Boylston Street at the finish line of the Boston Marathon. When it opened in 1972, it included a hall dedicated to John DeFerrari, and a bust of him was placed in its Boston Room.

DeFerrari was secretive, untrusting and suspicious. He took pride in his self-education, and liked to say that he "became a millionaire without the benefit of a banker, a secretary, a bookkeeper, an automobile, or a telephone." At the presentation of his gift to the trustees, according to newspaper accounts from 1947, he showed up wearing a new gray suit with its pockets shut tightly with safety pins so that pickpockets could not steal from him. A short time later, he would bequeath the library an additional $500,000 in downtown Boston real estate.

It's hard to account for the man's peculiarities. Perhaps he feared he would one day run out of money. His gifts were bequests, after all. When he gave them, he still owned his family's homestead in the North End, but it was shuttered, closed and surrounded by a steel fence. He was used to going there once a day, letting himself in and cooking a steak—his one meal of the day—on an old-fashioned stove.

When a reporter caught him there one day, the man asked DeFerrari the secret of his success. He responded, "I make good use of my time. I know the other fellow's business better than he does. I'm honest, too." Then he slipped inside his iron gate and (in a motion that seemed to be a metaphor for his life) snapped the padlock shut, saying, "I've talked too much now."

From our point of view, he said too little. John DeFerrari died in 1950 at the age of eighty-seven. His was a name known by many, a face known by few. His deeds touched lives for generations to come, though few would ever know it.

BANNED IN BOSTON—BORN IN QUINCY

In September 1929, the City of Boston still had a strict code that allowed it to control what kind of entertainment the citizens could watch. "Banned in Boston" was a popular phrase across the country, used to make fun of the bluestocking Puritanism that seemed arcane to outlanders.

It's an ill wind that blows no one good, and a play that was banned in Boston did a lot of good on the South Shore and elsewhere. The play was Pulitzer winner Eugene O'Neill's *Strange Interlude*, and the interlude to come was strange indeed. *Strange* had just finished a year and a half on Broadway, but its language was too raw for the Boston of its day.

Mayor Nichols said it was "a plea for the murder of unborn children, a breeding ground for atheism and domestic infidelity, and a disgusting spectacle of immorality." When asked when he'd seen it, he said he hadn't and wouldn't. Nor would anyone else; at least not in Boston.

Strange Interlude was aptly named. It began in the late afternoon, and then had an intermission so that people could go out to dinner. Then it resumed and went on late into the night. It certainly resolved the question of whether to go to dinner before or after the theater. And it was that strange dinner interlude that had the most memorable effects.

But who would see it now that it was banned in Boston? The towns of Lynn, Revere and Chelsea ran it, but most folks went to Quincy, where the railroad allowed Bostonians to disembark close to the Quincy Theatre on Hancock Street downtown. The theatre could accommodate an audience of 1,400. The Old Colony line scheduled extra trains at showtime and for after the play, while restaurants in Quincy prepared for the dinner intermission.

Showtime was 5:30 p.m. and the show ended at 11:00 p.m., and it was a big hit. The show remained in Quincy for more than a month and did better than it was projected to have done in Boston. Someone else did better than he thought he might, and that was Howard Johnson, owner of a restaurant that was packed each dinner hour with theatre patrons.

Howard Deering Johnson reached those heights after a lowly start. He left grammar school to work for his father, and later inherited his cigar business. But the business was in the red, so Johnson tried something else. He borrowed money and bought a small drugstore in Quincy. He put in a soda fountain that drew more customers than anything in the store. People would sit at the stools and order vanilla, chocolate or strawberry. They loved the creamy texture, for

Johnson was offering a new kind of ice cream, high in butterfat and cranked out by hand in the basement of his store. He got the recipe from an elderly German immigrant who had sold it out of a pushcart. Howard Johnson added to the same old three flavors, and he kept adding until he reached twenty-eight. Then he used "28 flavors" as a trademark. He also opened a beachfront ice cream stand and then a second, and then more. He added hot dogs and hamburgers to the menu, and called his Wollaston store Howard Johnson's Restaurant.

Then he got a loan and opened a restaurant in Quincy Square, where he sold fried clams, baked beans, chicken pot pies and the familiar hot dogs and ice cream, all at reasonable prices. Howard Johnson's was growing, but it took a banning in Boston and a play with a long dinner break to send him soaring. His restaurant was the best choice near the theatre, and word of mouth sent plenty of hungry and wealthy Bostonians to his door.

When the play opened, the stock market was riding high. Two days before it closed, Black Thursday, October 24, 1929, marked the beginning of the Great Depression. But even in those down days, Johnson was ready to expand. He began to buy roadside stands in eastern Massachusetts, and by 1935 had twenty-five of them. By 1940, the number reached one hundred. They were situated along highways up and down the Atlantic coast.

This franchising spread across America, and HoJo's orange roofs would presage the golden arches that would come decades later and replace them in the popular culture. Those orange roofs sat upon white buildings trimmed in sea blue, and most of them included a lunch counter, sit-down restaurant, ice cream stand and fast-food takeout. Johnson's place on the road to the New York World's Fair of 1939 was the largest roadside restaurant in the world in its day.

Symbolically, his locations made sense, for most Howard Johnson customers were travelers and America was quickly becoming a nation on the move. The first state-built, controlled-access highway was the Pennsylvania Turnpike. Johnson opened a restaurant at its Midway service plaza in 1940, a first. A trip on the turnpike to the Howard Johnson's became an early-day "destination" and a great way to spend a Sunday.

Johnson also won the franchise to build and operate restaurants along the Ohio and New Jersey Turnpikes. By the time of Pearl Harbor in 1941, the number of Howard Johnson's reached two hundred. Johnson took pride in the restaurants with his name on them. He made sure they were clean, the wait staff courteous and that standards were kept. He also introduced child-sized meals and high chairs to attract families.

However, during the war, most of his restaurants suffered because gasoline was rationed. People couldn't get enough to drive to a place on the highway, so they stayed home and the restaurants closed. That slowed Johnson down, but didn't stop him. He kept going by making candy and selling it to the armed services, along with other goods. When the war ended, he marched on.

He turned his attention to the travel aspect of his business, and started to build and franchise motels. The first of these opened in Savannah, Georgia, in 1954. Like his restaurants, his motels featured cleanliness and good service. Most of them had restaurants within them or next door, and by 1965 there were 265 of them, along with 770 restaurants.

Howard Johnson succeeded by finding a niche no one else was occupying. It wasn't just the orange roof that appealed, of course. Johnson dug into his New England roots and his architect designed a restaurant that looked like a colonial house with clapboard siding, windows with lots of panes and a cupola with a clock and weathervane. The weathervane depicted Simple Simon and the pieman, which became a trademark of the company.

Traditional stuff, you may think. And you'd be right. That was the mood of the America of that day. The menu was traditional, too. You could expect to get fried seafood, especially clams. The restaurants also offered "all the fish you can eat." The frankfurts were grilled in butter and served in toasted buns that rested in cardboard troughs. Macaroni and cheese was so popular that you could buy it packaged to take home.

Of course, you had to have dessert. If you were in a hurry to get back on the road, you could have an ice cream cone from a scoop that had a distinctive shape. Choose any of twenty-eight flavors. But you might want to stay and have a huge sundae made with one

of those flavors and topped with whipped cream, walnuts and a cherry. You could also have a sugar cookie with it, embossed with the company logo and therefore special.

Howard Johnson retired in 1959 and left the company to his son, although he continued to visit the restaurants to check for cleanliness. Styles changed as new ones were built, and competition from fast-food challengers brought down profits. Even so, in the mid-1960s, company sales were better than those of McDonald's, Burger King and Kentucky Fried Chicken together.

That changed in the 1970s. Howard Johnson died in 1972. By then the traditional menu and higher costs sent young families to McDonald's, where the whole family could eat faster and for less. HoJo's customer base grew grayer. In 1980, the franchise was sold. Restaurants and motels closed one at a time until only three are left: one in Bangor, Maine, and the others in Lake Placid and Lake George, New York. Attempts to revive the chain continue.

Howard Deering Johnson was a pioneer in building roadside restaurants. At its peak, the HoJo motif and reputation were widely known. It was born in Quincy when its mayor saw an opportunity and pounced, and it spread nationally when Howard Johnson did the same. Those of us who remember do so fondly.

MURDER AND MYSTERY

Boston has been the site of famous crimes and mysteries. Some have been real and well-known, and others have been real but not well-known. Then there's fiction like the mysteries from Robert Parker's *Spenser for Hire* or Dennis Lehane's *Mystic River*. In fact, Boston is the background for lots of books in the mystery-fiction genre. It took a New Yorker to say so. New York City mystery writer and National Public Radio contributor Jim Fusilli wrote in the *Wall Street Journal* that Boston was arguably "the epicenter of American crime fiction."

Then there are the "in-between" mysteries. Maybe they're real and maybe they're not, like the apparent murder of a young wife and her sailor boyfriend by her jealous but aged husband—a murder that wouldn't be discovered until years later, but which led then to the writing by Edgar Allan Poe of his *The Fall of the House of Usher*.

The following are a few examples of real ones:

THE HIGHWAYMAN

Some strange things have occurred in Boston, starting way back. Take the case of the Highwayman, James Allen. Allen had a long career in crime, including armed robbery. He was known for robbing travelers, and one of them was John Fenno Jr. of Springfield, whom he met on a road north of Boston.

Unlike most victims, the muscular Fenno did not hand over his wallet. Instead, he grabbed Allen and wrestled with him. Allen pulled a gun on Fenno, aimed it at his midsection and pulled the

trigger. He hit him square on, but Fenno didn't die because the buckle on his suspender deflected the bullet. Allen wasn't as lucky as Fenno. He was eventually caught and jailed as he had been many times before. This time would be his last. He became ill and lay dying, but dictated an account of his life of crime to his jailer. He called it *The Highwayman*, and he had it published.

As he thought back on his ill-spent days, Allen (who went by several other names) recalled the bravery of Fenno and directed that a copy of his biography be bound in Allen's own skin and given to Fenno. Fenno's daughter later gave it to the Boston Atheneum at 10½ Beacon Street, where it remains to this day.

BLOOD AND BONES ON BEACON HILL

As the year 1849 drew to a close, Boston was a prosperous city filled with Irish immigrants who were doing most of the manual labor. In contrast were the so-called Brahmins—wealthy and propertied—like Dr. George Parkman, who lived on Beacon Hill and knew John Adams, John Quincy Adams, John James Audubon and the Marquis de Lafayette.

Parkman is the subject of our account, and "accounts" are what he was about: he was a landlord. He owned lots of apartment buildings and collected the rents himself. He also lent money and spent a lot of time walking about Boston badgering people who owed him money. He didn't have to walk. He had plenty of money

and could have bought a horse, but he didn't want to spend the money. His chin stuck out as he walked, and he leaned forward and thrust out his walking stick. People called him "Old Chin." On a morning just before Thanksgiving 1849, a number of people saw "Old Chin," and some spoke with him. One woman held a dollar in her hand, with which she was about to pay for food, when Parkman strode up and demanded she give it to him because she owed him. He was Dickensian indeed.

That same Friday morning he ordered food for Thanksgiving and for his lunch at a grocery store near Harvard Medical School, now Massachusetts General Hospital. He had the food sent up to his house. In thirty-three years of marriage, he had never missed his 2:00 p.m. dinner with his wife—but George Parkman never came home that day. He was last seen at 1:30 p.m. wearing a dark frock coat, dark trousers, a purple satin vest and a stovepipe hat. He had gone to call on a man at the medical college whom he believed had tricked him with a bad business deal.

When Parkman didn't come home that night his family worried. On Saturday they anxiously made inquiries and then contacted the police, who posted a large notice urging people to come forward with information. While this happened, John Webster, the man at the medical school who'd met with Parkman Friday afternoon, was telling people his version of that meeting. Webster said that he had been to Parkman's home that morning to arrange to pay back money he owed.

Webster, a professor of chemistry and geology, had gotten into deep water financially. He liked to pretend that he was richer than he really was. His wife and four daughters all liked to wear nice clothes and go to fancy places, and Webster had gotten into debt paying for it all. He lived beyond his means in a nice house, and had to borrow to keep up. He had borrowed against the furniture in his house and also had gotten a loan from Dr. Parkman, using valuable minerals he owned as collateral.

Now he was telling people he had the money to pay Parkman back, and that's why the two men were meeting. Webster came to see the Reverend Francis Parkman (the doctor's brother) and his family on Sunday afternoon, two days after the doctor had disappeared, and

he said he'd read about it in the papers. He was almost too anxious to tell how he'd repaid the money he owed George Parkman on Friday afternoon at 1:30 p.m.

Webster told Parkman's family that the doctor had walked briskly out the door, calling back that he was going to go up to the city clerk to have the debt cleared from their records right away. Webster told them he was now worried that someone had robbed Parkman and the debt had not been cleared after all. Webster owed Parkman more than money. It was George Parkman who had gotten him his teaching job at Harvard. Yet, when he finished speaking to the concerned Parkman family, Webster made a stiff bow and left, never asking how they were doing or whether they'd heard anything.

They'd heard nothing. Search parties had looked day and night. The police had even dragged the river. Since Parkman had last been seen at the Medical College, police had looked twice through the laboratories and dissecting vaults, but had found nothing to indicate that Parkman had even been there. Yet he had been.

Parkman may have visited Webster for a different reason. Parkman's brother-in-law, Robert Gould Shaw (who would later gain fame by leading the first Negro regiment in the Civil War), told police that he had told Parkman that Webster had also borrowed money from him using the same minerals that he had already used to secure Parkman's loan. Parkman had become furious at hearing this.

Someone else was thinking about all this: Ephraim Littlefield, the janitor at Harvard Medical College. He and his wife shared the same floor with John Webster's labs—had done so for seven years—and he generally prepared the laboratory for Webster's lectures. He'd seen some peculiar behavior lately and he didn't understand what it meant.

A few days after Parkman disappeared, Webster had spoken with Ephraim Littlefield and asked him whether he had seen George Parkman at the school the week before. Littlefield said that he had, at around 1:30 p.m. on Friday. Webster asked whether Parkman had been in Webster's lecture room on that afternoon. Webster then repeated the details of his meeting with Parkman, just as he

had told them to Parkman's family. He was quite precise about the money he owed and the fact that the debt had been cleared. Then without another word, he walked off. This was more than he'd said to Littlefield in all the years they'd worked together and it made the janitor suspicious.

The police had been to see Littlefield a few days before, and had asked Littlefield some questions about the dissecting vault. Then, after the college had been searched, Webster had surprised Littlefield by giving him a turkey for his Thanksgiving dinner. This, too, was suspiciously out of character.

On November 27, Webster got to his office early. Littlefield heard him in there and got down on his hands and knees and peeked under the door. He could see Webster's feet and legs as far up as his knees, as the professor moved from the furnace to the fuel box and back, making eight trips in all. Later in the day, Webster burned something in his furnace. Littlefield knew this because the wall on his side had become too hot for Littlefield to touch. When Webster left, Littlefield let himself into the office through a window and made a strange discovery. Even though the box of firewood had recently been filled, it was almost empty. There were also wet spots on the floor. When the janitor placed his finger in them and put his tongue to his fingers, he noted that the liquid tasted like acid. It was all very strange.

The other strange thing was that people were starting to suspect Littlefield of some kind of foul play. Parkman had been seen entering the college, but not leaving. Had the janitor done something? As he reflected on the things that had happened, he realized that when the police had been there, their inspection had been quite casual. He thought they had not been thorough at all in their search and he decided to so some police work of his own. He knew the police had not searched the pit underneath the privy in Webster's lab, so he crawled in through a tunnel. There he found parts of a human body.

He went to the police and told them what he had found. They arrested Webster for the murder of Parkman. He tried to shift the blame to Littlefield, who would also have had access to the privy. As the police wondered about the rest of the body, the obvious

answer seemed to be that it had been burned. In fact, Littlefield had found a bone fragment in a furnace in the laboratory to which Webster had access and showed it to the marshal. That discussion led to a full search of the toilet area, with Webster brought in from the jail to observe. Webster watched in silence as they laid out the parts they had already found, and then he was carted back to jail.

The next day a coroner's jury went to the lab and examined a sink, the strange acid stains on the floor and the contents of the furnace (from which they extracted a button, some coins and more bone fragments, including a jaw bone with teeth). Then they dumped out a chest from which came a foul odor, and there was an armless, headless, hairy torso. It was clear that an unsuccessful attempt had been made to burn it. Just as they determined that the head had been sawed off, they found a saw nearby. Then they found a thigh stuffed inside the torso, while the heart and other organs were missing.

If the police had been able to use DNA analysis, they could have quickly drawn clear conclusions. But the day of DNA was yet to come. Other methods were used instead. A dentist identified the jawbone. He said he had made teeth for Parkman three years earlier and remembered that Parkman's jaw was an unusual shape (hence the name "Old Chin"). This, he said, was the jaw he had worked on. He was sure. Mrs. Parkman identified the body as her husband's from markings on the lower back. His brother-in-law said that he'd seen the extreme hairiness of Parkman's body and confirmed that it was his body.

In subsequent searches, they came up with bloody clothing belonging to Webster and then found the right kidney. They also tested the floor stains and learned that they were copper nitrate—a substance that can be used to remove bloodstains. The evidence was mounting for a good circumstantial case. However, there were no witnesses.

As much as the evidence appeared to point directly to Dr. John Webster, few could believe he was capable of such a terrible crime. Everyone knew that there was another person who had access to all the same areas—Ephraim Littlefield. In fact, Littlefield had a

reputation for digging up fresh corpses to supply to anatomy classes for twenty-five dollars each. He claimed to have discovered the body parts, but perhaps he had planted them there to frame the good professor.

Webster's trial, conducted early in the spring of 1850, received international attention. The grisly details of the murder heightened the public's interest, especially in light of Webster's continued protestations of innocence and the fact that both victim and accused were prominent figures at Harvard and in Boston society. Boston police estimated that as many as sixty thousand people visited the proceedings over the twelve days that court was in session. Newspapers around the country reported on the trial the way today's cable channels cover current cases.

The case against Webster rested on Littlefield's testimony that he had seen Parkman and Webster arguing on the day Parkman had disappeared, and on the remains discovered by the same Littlefield. The evidence against Webster seemed convincing, and he was sentenced to death.

But was Webster really guilty of the grisly murder of George Parkman? Some doubted it then, and some still do. More than 150 years after its conclusion, the case still receives attention. Although it may be impossible to determine now whether Webster was truly guilty, legal scholars agree that irregularities in the court proceedings prevented his receiving a fair trial.

THE CRIME OF THE CENTURY

It all happened in Boston's North End, just a short distance from the location of the molasses flood and right down the street from the Old North Church. When it happened it grabbed newspaper headlines all across the country and was called the "Crime of the Century."

It was the armed robbery of the Brink's Building on January 17, 1950, and it was the largest robbery in the United States up to that time. Though its $2.8 million in cash and checks doesn't seem large in today's terms, in 1950 it was real money.

Brink's is the company that collects money from banks and businesses in armored cars. Some of that money was kept temporarily in the new building at 165 Prince Street, where the company had moved only two years before. The new location stood at the corner of Prince and Commercial Streets at the foot of the Charlestown Bridge where the elevated T trains ran before being replaced by a tunnel. Today, the red-bricked path of the Freedom Trail runs by its main door.

The robbery was the culmination of two years of "casing" by the thieves—an outside and inside surveillance that was so thorough that all seven of the twelve gang members who were to enter the building on the night of the robbery had already been inside before. They had removed lock cylinders to key doors, made keys for themselves and replaced the cylinders. They had also researched the building's alarm system, knew the routines of employees and kept daily watch with binoculars from nearby buildings. By the time of the robbery, they could tell by the lights that were burning at night which employees were at work, where they were located and what they were doing—from outside the building.

They knew they would need a truck to haul the loot away, but wanted one with no distinguishing marks, so they stole a new green stake truck. After the robbery they cut it into pieces with a blowtorch.

They also held several practice runs. They had a lookout stationed on a nearby rooftop to signal whether conditions were right. Six times the operation was postponed. On January 17, 1950, seven men wearing Halloween masks came inside and passed through locked doors to the second-floor room where employees were counting money.

Police and the public were shocked by the robbery—its brazenness, its thoroughness and the amount of the theft. But little by little, clues were found. While questioning people in the area of the Brink's Building, the FBI learned that a 1949 green Ford stake body truck with a canvas top had been parked near the Prince Street door of Brink's around the time of the robbery. On February 5, 1950, some boys found several guns on a riverbank in Somerville, Massachusetts. One of the guns had been taken from a Brink's employee during the robbery. A month later, pieces of a green Ford stake body truck, cut up with a torch, were found in Stoughton, Massachusetts. The truck had been stolen in Boston in November 1949. Several suspects in the Brink's robbery lived in Stoughton.

Among the early suspects were a number of well-known robbers and criminals from the Boston area, such as Anthony Pino, Joseph McGinnis, Joseph "Specs" O'Keefe and Stanley Gusciora. A number of these suspects just happened to have alibis that involved them going somewhere at 7:00 p.m. the night of the robbery. O'Keefe and Gusciora lived near Stoughton, and after the green Ford truck was found, they came under intense scrutiny.

It took six years to bring indictments, but the unraveling of loyalties within the gang was their undoing. Eleven members of the gang eventually served prison time, but the bulk of the cash was never found. From time to time, in neighborhoods where gang members may once have lived, there are rumors of buried treasure, but as far as we know there have never been any "finds."

THE SLEEPWALKER

The Tirrell family has always been prominent in Weymouth, tracing its beginnings to England and to the early days of Weymouth. The family was at the forefront of Weymouth's shoemaking industry, starting with the town's first factory on Front Street and continuing through generations of Tirrells. Albert Jackson Tirrell was the black sheep of this distinguished family, notorious but nonetheless fascinating.

The murder in which Albert J. was involved took place in 1845 on Beacon Hill in Boston. It was bloody and grotesque, but that wasn't all that made it memorable. The novel maneuverings of Tirrell's defense attorney made the case the "O.J." case of its day.

Tirrell became known in the media as the "Boston Sleepwalker," but he was not from Boston and may not have walked in his sleep. He was, however, a slick and slippery cad and bounder, to use descriptions of the day. Albert was from a family of hardworking people who had become wealthy from their industry and good business sense. But Albert was neither hardworking nor sensible. He squandered his riches by living wildly and going on fun-seeking sprees. He was not just another good-looking bad boy with too much money for his own good. He was also a charmer, especially with women. He could use his vaunted charm to get himself out of difficult scrapes.

In Maria Bickford, his paramour, he had met his match. Maria was known as a woman of loose morals who used sex to get her way. She was married to the hapless James Bickford but was unfaithful to him, just as she would be to Tirrell. Albert was married, too, but that didn't slow him down. His wife was Orient Humphrey Tirrell, daughter of Noah and Susan Holbrook Tirrell of Middle Street in Weymouth. Even as the story opens, Tirrell and Bickford were being sought on charges of adultery—a serious crime in the mid-nineteenth century.

In the early fall of 1845, the *Boston Daily Evening Transcript* reported the arrest of a "young blood" in New Bedford. The story

said that he had been armed with a six-barreled pistol and a dirk (a dagger), and that he'd been arrested after a chase and was to be brought to Boston for trial on accusations of "some indelicacies with a young woman."

The *Transcript*'s story was rather discreet, but even in those days news outlets vied for readership, and when other papers picked up the story they also picked up the tempo and named names. The young blood was "Albert J. Tirrell, gentleman, of Weymouth." The term "gentleman," of course, referred to his social class, not his behavior.

Readers learned that the arrest was part of an ongoing case against Tirrell. The young rake had been indicted four months earlier on that serious charge of adultery, but had managed to flee and to evade the authorities until he was spotted in New Bedford. Bickford was with him, but she got away.

Tirrell was slippery, and he was able to skate once again. Despite his leaving town and resisting arrest, he was allowed to post bail. Not only that, but his wife, his friends and his relatives interceded on his behalf. They wrote to the county prosecutor and convinced him to put things on hold while they made an effort to reform Tirrell.

Perhaps it was his wealth or family name, but whatever the reason, the court agreed to a six-month stay. Albert was out again. But he wasn't reformed, nor would he be. He was more defiant of authority than ever and it took only one day for him to break his agreement and take up with his paramour at a disreputable lodging house on Beacon Hill. The building was on Cedar Lane Way at the bottom of the hill near Charles Street, and it was known as a place where illicit lovers kept assignations. A common term would have been a "house of ill-repute."

Six days later, the morning edition of the *Daily Mail* reported a case of murder and arson on Beacon Hill. A woman, Maria Bickford, had been killed by having her throat slit, and her bed had been set on fire.

You can probably picture what cable TV would do with this story today—frequent bulletins and updates, expert opinions, reports from friends and neighbors and lots of details about the people involved. Newspapers did the best they could, and made this a big

story. Those that were closest to today's tabloids managed to get the words "sex," "blood," "violence" and "Beacon Hill" into the same headline, while the more proper ones told the same story in less specific words that let everyone know what they meant without crossing lines of decorum.

The murder took place in the morning and that afternoon the *Mail* published an extra (or unscheduled) edition so that it could feed more details to an engrossed public. This 2:00 p.m. edition told readers that the dwelling where the mutilated body was discovered had regularly been used as a "house of assignation."

The victim, Maria A. Bickford, was from Maine. She had been separated from her husband for some time, and was described as having a "slight, graceful figure," and as "very beautiful." So now—even better—we had a beautiful woman whose throat had been slit by some beastly person.

Readers who continued below the fold would have learned that at 5:00 a.m. that day, Mr. and Mrs. Lawrence (the proprietors) and another young woman had heard a shriek upstairs, followed by a thud and then the noise of someone stumbling down the stairs and out of the building in a great hurry. They smelled smoke and came running.

Bickford was found with her jugular and windpipe severed, her hair burned by fire, her clothes burned off and her face charred and blackened by flames. There was plenty of blood and gore in that, but there was more to tell.

The walls of the murder room had been splattered with blood and several fires were set. A washbasin was filled with water that had been turned red with blood. An open razor, stained with blood, had been found at the foot of the bed and appeared to be the murder weapon.

Now the reader could follow the case in the role of detective. Pieces of clothing were found in the room, along with a most damning letter from "A.J.T." to "M.A.B." The *Mail* proclaimed that Albert J. Tirrell had almost certainly committed the murder. The press was ready to rush to judgment. In a preview of the cable competition that would grace a later time, Boston newspapers kept supplying additional details to enrich the story, and these appeared on the front page.

Keeping the story alive was a coroner's inquest. The young woman who lived with the Lawrences, and who had discovered the body, gave telling testimony. She had the unsettling name of Patricia Blood. Miss Blood testified that Maria Bickford had been staying at the house for about ten days and that Tirrell had stayed overnight at least once or twice.

On the afternoon before the murder, Blood said she had heard the couple exchange angry words. She'd mentioned it to Maria Bickford, who made light of it. Bickford had explained that the couple liked to quarrel because "they had such a good time making up."

The evening before the murder, Tirrell (known to the owners as "DeWolf") had left the house, but he returned hours later. Blood testified that Maria Bickford had come to her room at 9:00 p.m. and had asked for some water for Albert. That was the last time Bickford had been seen alive. Early the next morning the household was awakened by the commotion upstairs, followed by smoke and fire.

Police had made inquiries in the neighborhood, as they are wont to do, and had come across a man working in a stable who had information of interest to them. He testified that a young man who fit Tirrell's description came to the stable at 5:30 on the morning of the murder and asked for a horse to carry him to Weymouth. The young man had explained that he had gotten into some trouble and wanted to go to his wife's father. (Tirrell had been slick in the past, but this disclosure indicates that he may not have had his wits about him at that moment.) The coroner's jury also heard witnesses who identified the clothing found in the room as belonging to Tirrell. They joined the gentlemen of the press in concluding that Albert J. Tirrell had murdered Maria Bickford.

Tirrell, who was out on bail on the adultery charge, had fled from the crime scene, and while he was being sought, the newspapers in Boston and elsewhere built stories around the findings of the case and on suppositions they made about Tirrell and Bickford.

There were false sightings of Tirrell and even false claims of his arrest. Predictably, the press explored the background of the victim. Since she was both beautiful and somewhat mysterious,

Maria Bickford was a figure of interest. If you think today's media go awry, consider the spin those newspapers used in telling the story. One painted Bickford as a fallen but sympathetic woman, while her killer was depicted as a depraved predator who set upon an innocent woman. An anonymous poem described her as being "asleep in bed dreaming of her long-lost days of childhood innocence," as a sexual predator prepared to cut her throat with "cold, cold hands and ruthless steel."

Another reporter speculated on the dead woman's final thoughts. "Who knows the joys, the promised hope, that revealed itself for future life?" he asked, before concluding, "She was the victim of jealousy and revenge, and he who committed the bloody act, cannot go unpunished."

Tirrell, though, was used to going unpunished and did not want to have his record spoiled. He was on the run and getting ready to flee the country. When he had hired that horse on Beacon Hill, he had used it to ride to Weymouth, where some relatives facilitated his escape. We might call them accessories; undoubtedly, they thought they were being loyal. First they hid him and then they gave him money. A brother-in-law kept him company as he headed west and then north to Montreal. On November 8, he wrote his family that he was sailing for England that very day. And he did sail. At least he had boarded the ship, but bad weather forced it to return to port.

Meanwhile in Boston, the press, which had fired up the public, now carried reports of Tirrell's escape, and the fully engaged public was blasting the police for it. The mayor and the city council hadn't acted quickly enough. This assumed murderer had been allowed to get away.

In November, Tirrell sailed at last from Montreal, but not to England. His ship was bound for New York, where he would board a ship headed to New Orleans. Little did he know that his trip would end on the docks of New Orleans. In an example of inter-agency cooperation, Louisiana officials had been tipped off that the notorious Tirrell was headed their way. As his ship docked on December 5, Tirrell was arrested.

Held, but not humbled, Tirrell tried a spin of his own. He wrote a letter to the *New Orleans Picayune* proclaiming his innocence and blaming the press for inflaming public opinion against him. Tirrell

thus foreshadowed the blaming of the media by some of today's well-known figures. Tirrell was certainly selling papers. The story continued to get heavy play in the Boston press. The governor of Massachusetts (grabbing a few headlines of his own) announced that he was sending two officers to New Orleans to get Tirrell. When he was returned to Boston, he was placed in the Leverett Street Jail (now a hotel next to Massachusetts General Hospital). Crowds gathered, hoping for a glimpse of this Weymouth man who had become something of a celebrity.

Tirrell wasn't the only famous person in this case. He now had a famous lawyer, Rufus Choate, known for his melodramatic oratory. Choate argued that Tirrell either didn't kill Bickford or, if he did, that he was sleepwalking at the time and therefore was not responsible when he killed her and set the fires. It took the jury only two hours to discuss the matter, and they agreed with Choate. Tirrell was found not guilty of murder.

Choate's speech to the jury was described by a Harvard student and later well-known doctor, Benjamin Shurtleff, who was at the trial, as one of the most eloquent he had ever heard. Shurtleff knew eloquence when he heard it. His neighbor was the famous orator Senator Daniel Webster. In fact, the eloquent Choate would follow the eloquent Webster to the U.S. Senate.

All the same, Choate must have been a former-day Johnnie Cochran without the rhymes, considering the facts in evidence. Choate may also be viewed as a precursor of the "nuts or sluts" style of attacks on females that we have heard from recent political figures and defense lawyers. He spoke of Maria Bickford as "a low prostitute, a woman of dirks and knives…coarse, strong and masculine." He said she had repeatedly attempted suicide and seemed likely to have done so successfully this time.

Choate also defamed a female witness, saying her testimony should be completely disregarded by the jury. "A more base and more lying wretch never existed, a more coarse and reckless prostitute never lived." You could tell that, he said, by her "flippant and saucy expression, by her brazen countenance and every shade of her prostitute manner." That he was allowed to say such things tells us much about the courts of that day.

The lawyer then reconstructed the death scene to his own liking with this fanciful rendition:

> *Albert J. Tirrell, if he was there, was awakened from the insanity of sleep by the warm blood of the desperate suicide: half-awakening he sees the object of his licentious affection or love gasping by his side—he springs from the bed—takes the body in his arms and lays it upon the floor—stoops over her and presses upon her lips the last kiss of love and affection and then, crazed, half-sleeping and half-waking, seizes his clothes, rushes out into the yard and cried.*

The prosecutor thought all this was truly over the top and expected to poke holes in this nonsense with simple logic. But this was not the day for logic; drama was the currency of the moment. Tirrell was found not guilty of murder, and then not guilty of arson. Choate used the same sleepwalking and suicide arguments for arson as he had for murder.

John Langdon Sibley, who attended the murder trial on March 28, 1846, wrote, "The tone of public sentiment is such in regard to capital punishment that it is very difficult to convict a person for a capital offence…General opinion is that Tirrell is guilty; but it would have been unreasonable to have convicted him upon the evidence."

Tirrell had a winning hand and didn't play it. He used another lawyer for his adultery trial and the man didn't defend him as vigorously. He was convicted of adultery and sentenced to three years in prison. Tirrell served the full three years, and when he got out the newspapers used that occasion to call attention to the case once again. After his release from prison, Tirrell took the train back to Weymouth. Within a few weeks, his wife, Orient, became pregnant with their third daughter.

Tirrell served in the army during the Civil War, and was subsequently listed as a shoemaker and then a speculator, trader, huckster and then as unemployed. He died in 1880 of a brain hemorrhage. For a time, his three daughters lived with a neighbor while Albert and Orient took in boarders. None of their daughters ever married. All lived in relative poverty. The eldest daughter,

who was last to die, at age seventy-four, had been in the courtroom in Boston when her father had been tried. She was then three years old.

The bizarre sleepwalking case received coverage from the beginning in the Boston papers and eventually nationwide. A British website on famous murders of the nineteenth century lists the Tirrell case alongside well-known cases like Jack the Ripper. The Tirrell-Bickford case received prominence because of the brutal nature of the killing, the successful use of the sleepwalking defense for the first time and the sleaziness surrounding it. The perceived injustice of the sentence gave the matter resonance, too.

The sleepwalking defense was used a number of times after that. Recently (1986) there was the case of Kenneth Parks, who claimed he was sleepwalking when he drove a car fourteen miles and killed his mother-in-law. He, too, was acquitted. On June 25, 2004, a man in Long Beach, California, who had a history of sleepwalking tried the defense but was found guilty of murder, nonetheless.

The Tirrell case resulted in a book, *The Prostitute and the Somnambulist: Albert Jackson Tirrell—Trials for Murder, Arson and Adultery.*

THE SACCO-VANZETTI CASE

Nicola Sacco and Bartolomeo Vanzetti were Italian immigrants and avowed anarchists who were convicted in 1923 for a pair of murders during an armed robbery in Braintree, although their alibis placed them far from the robbery. Though the murders and robbery of which they were convicted took place south of Boston, in the town of Braintree, the story of Sacco and Venzetti is often seen to have a Boston connection.

Rebellion against tradition has been a signature element in Boston's history—from rebellion against the British to the rebellion of the immigrant groups against the ruling Brahmin class. The facts of the crime and the trial of the accused are interesting, but the staying power of the case stems from the perpetual belief that innocent men were convicted and executed and that their real crimes were being immigrants and politically incorrect.

Worldwide protest accompanied the arrests of Sacco and Vanzetti in 1920, and attention to the case grew after their 1923 convictions. During their unsuccessful appeals and in the period leading to their executions on August 23, 1927, artists throughout America, in Italy and around the world protested the proposed action of the state against two individuals whose political views were opposed to those of the establishment.

On April 15, 1920, a paymaster for a shoe company in South Braintree, Massachusetts, and his guard were shot and killed by two men who escaped in a car with two or three other men and more than $15,000. It was thought from reports of witnesses that the murderers were Italians. Because Nicola Sacco and Bartolomeo Vanzetti had gone with two other Italians to a garage to claim a car that local police had connected with the crime, they were arrested. Both men were anarchists and feared deportation by the Department of Justice. Both had evaded the army draft. Each was carrying a gun at the time of the arrest and they also lied to authorities. Neither, however, had a criminal record, nor was there any evidence of their having had any of the money.

The trial started on May 21, 1921. The main evidence against the men was that they were each carrying a gun when arrested. Some people who saw the crime taking place identified Vanzetti and Sacco as the robbers, but others disagreed. Both men had good alibis: Vanzetti was selling fish in Plymouth, while Sacco was in Boston with his wife having his photograph taken. The prosecution made a great deal of the fact that all those called to provide evidence to support these alibis were Italian immigrants.

In July 1921, they were found guilty after a trial in Dedham, Massachusetts, and were sentenced to death. Many then believed that the conviction was unwarranted and had been influenced by the reputation of the accused as radicals when antiradical sentiment was running high. The conduct of the trial by Judge Webster Thayer was particularly criticized. Later, much of the evidence against them was discredited.

In 1927, when the Massachusetts Supreme Judicial Court upheld the denial of a new trial, protest meetings were held and appeals were made to Governor Alvan T. Fuller. He postponed the execution and appointed a committee to advise him. On August 3, the governor announced that the judicial procedure in the trial had been correct. The execution of Sacco and Vanzetti on August 22, 1927, was preceded by worldwide sympathy demonstrations.

The two men were, and continue to be, widely regarded as martyrs. No single account nor any ballistics test has been able to put all doubts about innocence or guilt completely to rest, despite the two most recent books that have claimed to have done so, while arriving at almost directly opposite conclusions. However, new ballistics tests conducted with modern equipment in 1961 seemed to prove conclusively that the pistol found on Sacco had been used to murder the guard. This has led some authorities to conclude that Sacco was probably guilty of the crime, but that Vanzetti was innocent. In 1977, Governor Michael Dukakis issued a proclamation declaring that Sacco and Vanzetti had not received a fair trial and advocated that "any stigma and disgrace should be forever removed" from their names.

The case was the subject of Maxwell Anderson's play *Gods of the Lightning* and is reflected in his *Winterset*. It is also the subject of Upton

Sinclair's novel *Boston* and of sonnets by Edna St. Vincent Millay. However, in written accounts, the two men are generally portrayed as symbols rather than as real men with real characteristics. We don't know much about them. It takes a great deal of digging to uncover simple facts about their lives. They were and continue to be a cause célèbre. What happened to them has become more important than what they may have done or who they were.

However, they have become a part of Boston history, though the only parts of the case involving Boston are Sacco's alibi that he was at the Italian embassy in that city when the crime was committed (which was not believed) and a rally in support of the suspects.

After the executions, the Sacco-Vanzetti Defense Committee proposed that a memorial building, named Freedom House, be erected in the vicinity of the Massachusetts State House in Boston to continue the research and advocacy around Sacco and Vanzetti and other individuals who have not found justice at the hands of the American judicial system. Gutzon Borglum, sculptor of the four presidents on Mount Rushmore, created a bas-relief to encourage subscriptions to underwrite the cost of creating Freedom House. The plaster rendering, a first draft of the proposed sculpture, was unveiled at the Sacco-Vanzetti Memorial Meeting of August 23, 1928. Borglum completed the final sculpture in bronze in 1930.

When plans for the memorial building did not materialize, the Memorial Committee sought to have the sculpture erected in a public place. It was offered both to the City of Boston and the State of Massachusetts in 1937, on the tenth anniversary of the executions. The committee never received a formal reply or acknowledgement of this offer, though it was reported that Governor Hurley considered the offer "absurd" and protested viewing the men as "martyrs." The offer was renewed in 1947 unsuccessfully, even though such luminaries as Albert Einstein and Eleanor Roosevelt urged its acceptance. The offer was rejected again in 1957. The fate of the actual bronze sculpture is not known at this writing. But the story, and its Boston connection, doesn't end there.

In 1960, in a garage workshop that was being renovated, the plaster cast was found by a now unknown dustman and given to

Aldino Felicani, a leader of the Defense Committee and North End printer who printed the church programs of the Community Church of Boston. Felicani requested that Community Church provide a home for the plaster sculpture, and the church accepted the work "on permanent loan." The Boston Public Library held a major symposium on the Sacco-Vanzetti case in 1979, and the church was invited to participate. In anticipation of the transfer of the plaster bas-relief to the library, three metal castings were made.

In 1997, on the seventieth anniversary of the executions, Boston's first Italian-American mayor, Thomas Menino, accompanied by Governor A. Paul Cellucci, formally accepted the plaster sculpture for the City of Boston and pledged that a bronze casting would be erected in a public location in the city. Due to the perceived fragility of the plaster, the Community Church of Boston has agreed to loan its aluminum casting to the city for the purpose of creating the new work in bronze. The press conferences accompanying the 1997 announcement indicated that the newly cast work would be unveiled in the year 2000.

A bas-relief of the sculpture was placed in the Boston Public Library, but the factory building on Pearl Street in South Braintree, where the two victims (one an Italian immigrant) were shot, has been torn down and replaced by a shopping mall. No marker commemorates their death.

THE BOSTON STRANGLER

In the mid-1960s, women in the Boston area were struck with terror by a serial killer known as the Boston Strangler. He killed women of all ages in all parts of the city. These were not prostitutes like the victims of Jack the Ripper. They belonged to no particular group of women. Most of them led quiet, respectable lives. That made it even worse. Anyone could become a victim.

These women did not meet their ends on the streets or in alleys, but in their own homes. In each case, the killer strangled his victim, usually with an article of her own clothing. He used intelligence to get inside, usually by convincing his victims to let him in. In a

few cases, he gained access before the victim got home and then waited for her arrival. None of the twelve victims put up a fight. All went quietly.

Although the public and much of the media believed the stranglings were the work of one man, the police did not think so. Erle Stanley Gardner, creator of the *Perry Mason* stories, wrote an article in May 1964 called "The Mad Strangler of Boston," in which he noted, "Police are not at all certain those stranglings were the work of one man; but until they catch the culprit…they cannot be positive."

Gardner suggested the killer's method: The phone rings at the home of the prospective victim. An assured voice, supposedly from someone representing a utility company, says, "This is the serviceman. We wanted to be sure you were home; we'll have a repairman there in about ten or fifteen minutes to make an inspection."

Ten minutes later there is a knock at the door. The young woman asks, "Who's there?" and is reassured when the voice says casually, "The repairman, ma'am."

"Oh," she will say with relief, "they telephoned about you."

She opens the door, and while he goes to the kitchen she busies herself elsewhere in the apartment. Then, perhaps, the light of a window will be cut off as a shadow falls over her shoulder, or she may hear the sound of a stealthy tread behind her.

She whirls and opens her mouth to scream. But it is too late.

The murders began in June 1962, when fifty-five-year-old Anna Slesers was murdered in her apartment just after dinner with a cord from her own housecoat. The residence appeared to have been burglarized, but on closer inspection, police discovered that nothing of value had been stolen. In addition, Slesers's body had been lewdly arranged, and there was evidence of sexual assault.

Over the next eight weeks, five more women were murdered, each living alone and each killed in a similar manner, usually with an article of her own clothing. All of the women had been sexually assaulted with unknown objects, their semi-nude bodies set in sexual positions—facts that were kept from the news media at the time. Of the six women, Slesers was the youngest, with ages ranging up to seventy-five-year-old Ida Irga, the fifth victim.

Then, for a three-month period, there were no new attacks. When the killings started again, with the December murder of Sophie Clark, the pattern had changed. Clark was different from the earlier victims in several ways. She was young and black; she shared her apartment and was popular with fellow students at the Carnegie Institute of Medical Technology. And, for the first time, evidence of semen was found near the body.

During his killings, the Strangler had apparently disturbed only one thing in those rooms: the drawer containing Miss Clark's stockings. He would hardly have made his search of the apartment looking for the stocking (the murder weapon) after Miss Clark had entered the apartment. Unless she was unconscious, she would have heard him moving around and opening drawers.

It was later discovered that a man had approached another tenant of Clark's apartment building, claiming he had been

sent to paint her apartment. When the woman mentioned that her husband was asleep in the apartment, the man became very flustered and left in a hurry. This technique of approach was one that Gardner had, in fact, highlighted from the report of the second victim, Nina Nichols.

A few minutes before her death, Mrs. Nichols had been talking on the telephone with her sister. In the midst of the telephone call, she said, in effect, "Excuse me a moment, my doorbell is ringing. I'll call you back in just a few minutes." Mrs. Nichols did not call back. This was a most valuable clue as to the modus operandi of the Strangler. He was on occasion a person who rang doorbells and, with some plausible story, was admitted to the apartment.

The last five victims were killed between December 1962 and January 1964. Along with Clark's, these deaths were much more spread out in time, and five of the six women were under twenty-five years of age. Many people believe to this day that the final six murders were committed by another person—if not several.

Gardner described the police's increasing desperation. They had to correlate the names of all acquaintances of the victim with the names of acquaintances of other victims. In addition, they had to start running down all persons who had recently been released from institutions who had a history of sex crimes and who were living in the vicinity of the crimes. In the course of these routines, the police investigated six thousand persons.

At one point, the Boston police called for the services of a local clairvoyant. Even after Edward W. Brooke, the attorney general of Massachusetts, personally took over the case (and called in a second psychic), it was more than a year before any leads were developed.

The first break was in 1965, a year after Gardner's article was published, and it came from an unlikely source: F. Lee Bailey, the lawyer of George Nassar, a highly intelligent convicted murderer in the local prison's psychiatric ward. A client of Bailey's had told him about Albert DeSalvo, a man convicted of many burglaries and a few rapes. DeSalvo was a man who believed he would spend the rest of his life in the psychiatric institution.

According to the story, DeSalvo and Nassar concocted a plan by which Nassar would turn him in, collect the reward money and split it

between them. DeSalvo confessed to the eleven known murders, along with a twelfth murder and a thirteenth attempt, in specific detail—extraordinarily exact at times, but at others quite incorrect. DeSalvo, who had an extremely low IQ, was found guilty, even though the few eyewitnesses all ruled him out as the Boston Strangler. In fact, two of them fingered George Nassar for the killings.

No one ever went on trial as the Boston Strangler. However, the public believed that Albert DeSalvo, who confessed in detail to each of the eleven "official" Strangler murders, as well as two others, was the murderer. When DeSalvo confessed, most people who knew him personally did not believe him capable of the vicious crimes, and today there is a convincing case to be made that DeSalvo wasn't the killer after all.

The controversy surrounding the Boston Strangler continues to this day. Albert DeSalvo was killed in prison in 1973, but in December 2001 DNA was taken of his remains and compared with evidence from the crime scenes. The test came back negative.

Casey Sherman, a nephew of victim Mary Sullivan, went on a ten-year quest to find her killer. He formed the assumption that Albert DeSalvo was not her killer—indeed, Sherman thought he may not have killed anyone. He was joined in his quest by relatives of several victims and some of Albert DeSalvo's relatives.

On Friday, October 26, 2001, a report by the Associated Press described how Albert DeSalvo's body had been exhumed from a grave site in Massachusetts and taken to a forensic laboratory in York College, Pennsylvania, for examination. The following Saturday an autopsy was conducted on the remains in the hope of attempting to prove DeSalvo's innocence of the murders and possibly to identify his killer.

James E. Starrs, a professor of forensic sciences at George Washington University, led the team of scientists who performed the autopsy. Starrs is best known for his identification work on other high-profile cases, including the Lizzie Borden hatchet murders, the Lindbergh baby kidnapping and the murder of the outlaw Jesse James.

He told the AP, "The family has been unsatisfied all these many years concerning the death of Albert DeSalvo and failure to find

anyone guilty of the death." On Thursday, December 13, 2001, *Court TV* reported that DNA evidence taken from Mary Sullivan's remains did not provide a match to Albert DeSalvo. During a news conference, James Starrs told reporters, "We have found evidence and the evidence does not and cannot be associated with Albert DeSalvo."

Starrs made it very clear that the evidence only cleared DeSalvo of sexual assault. While he did not give details of the analysis, he told reporters, "If I was a juror, I would acquit him with no questions asked."

Casey Sherman, who had always doubted that DeSalvo killed his aunt or any of the other victims attributed to him, said he felt vindicated by Starrs's finding: "If he didn't kill Mary Sullivan, yet he confessed to it in glaring detail, he didn't kill any of these women."

Sherman also told reporters that, prior to DeSalvo's confession, police had what they considered "a prime suspect" in Sullivan's murder but dropped the case after DeSalvo confessed. Sherman urged police to "go after the real killer" who, according to him, is still alive and living in New England.

In 2003, Sherman completed *A Rose for Mary: The Hunt for the Real Boston Strangler.*

SINGULAR EVENTS

A BASEBALL MIRACLE

Americans love to hear about sports miracles. On a recent program, the "Miracle on Ice" victory of the U.S. Olympic Hockey Team over the Soviet Union in the 1980 Olympics at Lake Placid rated as the number one most thrilling sports event.

Less well-known, but still in the miracle class, is the victory of the Boston baseball team of 1914. In a year when Babe Ruth hit his first home run and the world was going to war for the first time, this team staged the greatest second-half run in the history of any sport.

The 1914 Boston team proved that baseball has a long season and it can be filled with ups and downs. This team had some unusual characters. Its manager, George Stallings, was a genius at inside baseball, but he had some crazy players. One of the weirdest was the shortstop, Rabbit Maranville, who once jumped into a hotel fish tank on a dare from the other players. Many of the players acted wildly at night but usually managed to stay out of jail and come to play the next day.

The team had two pitchers who won twenty-six games apiece, and eleven outfielders who took turns playing the three outfield positions. The team was not taken seriously in the pre-season, and they made the seers look good because by July 19 they were in last place, fifteen and a half games behind the leading New York (of course) team.

They had managed to get out of last place for the first time about a month before that, but had gone right back into the cellar the next

day. Manager Stallings had been working with the team, though, and he thought he had them going in the right direction. "Give me a club of only mediocre ability," he said, "and if I can get the players in the right frame of mind, they'll beat the world champions." That was optimistic indeed for a team whose record for the first half of the season was 33–43.

But on July 19, they swept both ends of a double-header and moved into seventh place. They celebrated as if they had won the World Series. Stallings told them, "Now we'll catch New York. They won't be able to stop us."

The team batted only .251 and hit only thirty-five home runs that year, but their pitching was solid. They had three good pitchers, and would find another one before the season was over. After opening their Western swing with that double-header victory, they moved onto the next city and swept the series, allowing the home team no runs in any of the games.

In one of the games, the teams were tied 0–0 in the top of the ninth with Rabbit Maranville stepping up to the plate. Stallings whispered to him, "Get on somehow, even if you have to get hit." With the count of no balls and two strikes, Rabbit inched closer to the plate and took one for the team, right on his forehead! The umpire said, "If you can walk to first base, I'll let you get away with it." That forced in a run and it stood up in a 1–0 victory.

On August 10, riding a nine-game winning streak, the team moved into second place, six and a half games behind the now fidgety, nervous New York team. New York sportswriters tried to relieve worries. "The same thing happened in 1912. Two teams made a run but we won by ten games," they remembered.

Boston moved east to play three games in New York and swept the series, winning the final game in ten innings. Eight days later, on August 23, they took over first place.

But they couldn't stay there. They went into a slump and fell to third place. They seemed to have lost their spark. It would be the comical Maranville, with the help of his second-base partner, Johnny Evers, who would get them back on track.

They were in Chicago when a player with a tough reputation, Heinie Zimmerman, tried to steal second against them.

Zimmerman came barreling down, but Evers put a hard swipe tag on him, making Zimmerman angry. Maranville was afraid of what he would do to Evers when he got up, so he sucker punched the big man from behind, knocking him onto his back.

Zimmerman hadn't seen who had hit him, but he overlooked the slight shortstop and blamed the big third baseman instead. "I know who hit me. It was Moose Whaling," exclaimed Zimmerman, who was being held back from attacking Whaling. The sly Maranville casually escorted Zimmerman off the field. "Whaling didn't hit you. I did," Rabbit explained to Zimmerman. But Zimmerman didn't believe him. "No midget like you could give me a belt like that. It was Whaling or Butch Schmidt."

As they reached first base, Zimmerman went after Schmidt, the Boston first baseman, resulting in an all-out brawl. Later, from his teammates, Zimmerman found out that it really had been Maranville who had sucker punched him, but he was too late. The excitement seemed to wake up the Boston team and they began to win again. On September 2, they were back in first

place. They traded first and second place with New York back and forth for the next week.

On the first weekend of September, the two teams were tied as they met at Fenway Park for a crucial three-game series. The teams split the first two games, but Boston won the third game and went on to win twenty-five of their last thirty-one games to win the pennant—truly a miracle season.

Philadelphia had won the pennant in the other league and would face Boston in the World Series. The Philly team was a heavy favorite and looked down their noses at their Boston opponents as "bush leaguers." But Boston surprised everyone by winning the opener on the road in Philadelphia. That made the second game critical. Game two was scoreless into the top of the ninth. Charlie Deal doubled to lead off the ninth for Boston, but was caught off second by a snap throw from the Philadelphia catcher. Instead of trying to get back, he ran safely to third and scored on a single what would be the winning run, sending Boston home with a two-game lead.

"We won't be coming back. It'll be all over after two games in Boston," Stallings stated. But it remained a tight series. Game three went to extra innings, tied at two. In the top of the tenth, Philly made it 4–2, so this called for another comeback. The Boston catcher, Hank Gowdy, led off the bottom of the tenth with a home run, but the next man made an out.

Then Herb Moran walked and was singled to third by Evers. A sac fly tied the game 4–4, and it went to the twelfth. This time Gowdy started things with a double and Stallings put in a pinch runner. Herb Moran bunted back to the pitcher, who whirled and threw to third to catch the lead runner. But the throw was wild. The third baseman lunged for it, but the ball went into the outfield and Boston had won, the longest World Series game ever played until that time.

After Stallings cancelled train reservations to Philadelphia, Boston won game four, 3–1. They were the 1914 World Champions.

This team would make only one more appearance in the World Series. In 1948, they lost in six games to the Cleveland Indians. Five years later they moved to Milwaukee and after that to Atlanta. The year 1914 will be remembered in baseball history as a miraculous year because of the miracle Boston Braves.

A Sticky Situation: The Great Molasses Disaster

January 15, 1919, was a warm day in Boston. It had been in the forties and there was no snow on the streets. Things seemed to be looking up. The Boston Red Sox had won the World Series that fall for the fifth time. They didn't know it, but it would be eighty-six years and much hardship before they won another.

World War I had ended just two months before. Troops were coming home to Boston, and our president, Woodrow Wilson, was in Europe trying to get a fair peace treaty. He would fail. Another president who didn't fail at much of anything, Theodore Roosevelt, had died two days before. A future president, John Fitzgerald Kennedy, grandson of the former mayor of Boston, would be two years old in May. The nation was recovering from a great pandemic of flu that had killed twenty million people. Another disaster of a smaller magnitude but greater drama loomed on the horizon that sunny January day.

It was lunchtime and people were enjoying the mild air outside along Commercial Street in Boston's North End. The breeze off the ocean was bringing the aroma of salt air. Commercial Street ran along the waterfront before joining Atlantic Avenue near Long Wharf and Quincy Market.

Overlooking Commercial Street stood Copp's Hill Burying Ground. Someone standing there could easily have seen the masts of "Old Ironsides" just across the water in Charlestown. If that person had turned and looked down the hill, he would have seen the white steeple of Old North Church, where two lanterns had been raised in 1775 as a signal to Paul Revere.

Revere was there too that day, or at least his statue stood just around the corner from the church. He was mounted on his horse and ready to go. A rider on horseback would have been in good position for what was about to happen on that January day.

Looking out onto Commercial Street again, that Copp's Hill observer would have seen an elevated train (the ancestor of today's T) headed in his direction. The tracks ran high above Commercial

Street, nearly at eye level as he looked. But presently they would droop down like a lolling tongue onto Commercial Street and that train would come close to spilling off.

Across Commercial Street on the water side stood a giant steel storage tank set into a concrete base. The tank's seams were stitched together with rivets, not bolts. It had been built to hold a semi-liquid product used to make both rum and baked beans, products prominent in Boston history. The tank could hold two and a half million gallons of the stuff. It was fifty feet tall, ninety feet across and it had just been filled—with molasses.

At about 12:30 p.m., as the elevated train clattered along above the street, a mighty roar abruptly drowned out its clattering. The molasses tank had split. Its rivets were popping with a sound like machine gun fire, releasing a choking brown wave of molasses, fifteen feet high, that weighed fourteen thousand tons. That "tidal wave" now ran down Commercial Street at thirty-five miles per hour, knocking down everything in its way.

One section of the steel tank was thrown across the street, knocking out one of the supports for the elevated railroad. The once-clattering train screeched to a halt just before it reached the spot where the track ahead sagged down into the flood of molasses. The wave had toppled houses and crushed buildings. People were swept off their feet and drowned in the tide. As the wave spread out, it covered blocks of downtown Boston at a depth of two or three feet before subsiding.

When rescue workers arrived, they had to wade through the sticky molten molasses with boots on. Over time, molasses was tracked everywhere, even fifty miles west to Worcester.

When the flood subsided, the area had to be hosed down using ocean water to wash the molasses into Boston Harbor, a harbor that had once before been turned brown, that first time by tea shortly before the lanterns had brightened the sky for Paul Revere. Now molasses turned it brown again. Molasses was everywhere, sticky and vile. Decades later, people would say they could still smell the odor of molasses on a warm day.

What caused the great molasses flood? A lawsuit took six years to decide. The court ruled that the tank had broken because the

inspections weren't tough enough, and the company that owned the tank was held to blame. Money wasn't worth as much then, but it still cost about $1 million to settle.

There's more to tell. You can read the fascinating details in Steve Puleo's book, *Dark Tide*.

SUBWAYS ARE MORE THAN SANDWICHES

In the dying years of the nineteenth century, Boston faced the worst clogging by traffic it had ever known. The worst of it ran along the major artery of Tremont Street by Boston Common, where trolleys and carriages daily became hopelessly mired.

The city struggled to solve the problem until at last a new traffic commission decided that subways would be the answer. This would be unique. You see, there were no subways in all of America at the time. London's "tube" had become the world's first only five years before, and there were two others in Europe.

This seemed to be a unique opportunity to lead the country in new technology. But not so fast! There was opposition to building a subway. Some called it a "monstrosity" that would destroy the beauty of the Boston Common. Owners of businesses were afraid they would lose customers if people were underground. People who owned buildings thought the foundations of those buildings might be weakened. There were even fears of bad air and evil spirits underground. A local undertaker said, "I don't believe in a tunnel or a subway. I expect to be a long time underground after I am dead, but while I live I want to travel on earth, not under it." You can see that people thought differently in those days, not much more than a hundred years ago.

When the vote was taken by the people of Boston, the subway won by a sweaty-browed margin: 15,483 to 14,212. In 1895, the digging began along Tremont Street. A trench was dug, supports were raised and covered and then the earth was put back. Then walls, floors and ceilings were put in place and stations and lighting were put in. Track was laid. It all took about two years—sort of a "small dig."

In 1897, America's first subway began its run between Park Street and the entrance to the Public Garden. Just one small step for mankind, and hardly a good stretch of the leg. But that was just the beginning. The subway got traffic off the streets and once people saw how good it was, they wanted more of it. So the digging, tunneling and building continued.

And building up is what came next. An elevated railway was built that ran from Roxbury to Boston and over a new bridge into Charlestown. This was not just any bridge. This bridge was the longest in the United States at the time. An elevated railway was cheaper than a subway, but noisier and uglier. It was the only one built in Boston and the last of it was torn down several years ago. Good riddance.

Next came a tunnel for subway trains under Boston Harbor to East Boston. Now the engineering got tricky, and this was dangerous digging. New York had tried twice to dig tunnels under water like these, but they had failed. Boston succeeded. The newly built tunnel was then connected to the existing subways. Now we had a system.

The fourth part of the subway system was a tunnel from Harvard Square in Cambridge to Andrew Square in South Boston. That was a long tunnel by the standards of the time. It ran under water more than once, and it also required boring beneath Beacon Hill near the State House. All of this took nine years and was completed in 1918.

This original subway system lasted an incredibly long time and much of it is still in use today. If you want to understand how old Boston is compared with the rest of America, ride the T— or most of it anyway. The subway stations of the original lines are still in use, and 95 percent of the tunnels are still used. They are now called the Red, Orange, Green and Blue lines. The Red line honors Harvard University, whose official color is crimson. Harvard was the last stop on the line until fairly recently. Orange was the original name of much of Washington Street where that line runs. The Green Line passes through the "Emerald Necklace" park system, and the Blue line runs beneath the water. There's a certain folksy logic to it if you plod along patiently. And you can still ride these lines today.

Boston tends to keep things if they work in a passable way. City administrators and even the citizens take it for granted that you, the visitor, will catch onto the Boston way of doing things. They may not bother to put up signs and directions because that's how it's always been done. It can be frustrating, but it's also fun. And it's part of the "Boston Way." For an interactive experience in all of this, take the T.

Part Four

FOOD FOR THOUGHT

COOKIES TAKE THEIR TOLL

You have certainly had chocolate chip cookies many times, but people like George Washington, Abraham Lincoln and Mark Twain weren't as lucky as you because they hadn't been invented in their days.

Ruth Wakefield of Massachusetts is the one to blame if you think cookies are making you fat. Ruth graduated from Framingham State College and worked as a dietitian and lectured on food until 1930, when she and her husband, Kenneth, bought a tourist lodge in Whitman (about twenty-five miles south of Boston). The Cape Cod–style house had been built in 1709, and at that time it had served as a haven for road-weary travelers. There, passengers paid tolls, changed horses and ate home-cooked meals.

When the Wakefields bought it more than two hundred years later, they decided to build on the house's tradition, so they turned it into a lodge and called it the Toll House Inn. Today, a place like the Wakefields' would be called a motel or perhaps a bed-and-breakfast. It was located on what was then the major highway between Boston and New Bedford. The road started in Weymouth Landing and today is called Route 18. The Toll House Inn was partway between Boston and New Bedford. Since travel was slow in those days, and Route 18 was a narrow road, people often looked for a place to stop for a meal or to spend the night.

Ruth prepared the meals for those who stayed at Toll House Inn or those who stopped there. She specialized in colonial-style cooking,

the kind you would have found in Boston during the 1700s. But she became most famous for her incredible desserts. Her reputation and that of her restaurant grew by word of mouth and people started coming there from all over New England.

One day in 1930, Ruth was preparing a batch of Butter Drop Do cookies, a recipe from colonial days. The recipe called for baker's chocolate, but she had run out, so she cut into a bar of semisweet chocolate that Andrew Nestlé of the Nestlé Chocolate Company had given her. She broke the semisweet chocolate into tiny bits and added them to her dough, expecting it to melt and mix together with the other ingredients to make all-chocolate cookies. But—uh oh! It didn't. The chocolate bits held their shape and softened into a creamy texture. She used it anyway and called her new invention the Toll House Cookie.

It became a favorite at the inn. Her recipe was published in a Boston newspaper and then in other New England papers. When people saw that they were made from Nestlé's semisweet chocolate bars, the sales of those skyrocketed. Andrew Nestlé and Ruth Wakefield struck a deal. Nestlé would print the Toll House Cookie recipe on its packages and Ruth Wakefield would have a lifetime supply of Nestlé chocolate.

Nestlé began to score lines on its semisweet bars and included a special chopper in the package for cutting the bar into small morsels. Then, in 1939, Nestlé had a better idea, and began offering Nestlé Toll House Real Semi-Sweet Chocolate Morsels. The rest is chocolate chip history.

Ruth continued to cook up a storm, producing a series of cookbooks, including *Ruth Wakefield's Recipes: Tried and True*, which went through thirty-nine printings. She and Kenneth sold the Toll House Inn in 1966 to a family that tried to turn it into a nightclub.

In 1970, it was bought by the Saccone family, who turned it back into its original form. The Toll House burned down, however, on New Year's Eve in 1984.

Once the patent had expired, many cookie manufacturers began to produce the cookies, calling them by a generic name, chocolate chip cookie. Just seventy-five years ago, nobody had ever heard of a chocolate chip cookie. Now it's the most popular kind in America. About ten billion are eaten every year. That's fully half the cookies eaten in America. Are you doing your fair share?

BOSTON COOKERY

Like most parts of the world, Boston and New England have particular foods and ways of preparing foods that are associated with this area. Some of them are known the world over. With a seafaring history, and a location on one of the world's best harbors, Boston is especially well-known for its seafood, particularly fish like cod and haddock (often called scrod) and shell foods like lobster, clams and scallops. But New England also has a farming tradition, and the early colonists depended upon foods they could raise themselves and prepare easily. Foods like corn on the cob and other vegetables, corn breads, cranberries and blueberries were used by early Bostonians.

It was in New England that the nation's first cookbooks were written and printed. The Boston Cooking-School Cookbook was made by Fannie Farmer, a well-known teacher in the early part of the last century. It is still used today. More recently, another Bostonian, Julia Child, used television to teach us about French cooking. More typically, New England food is simple—not fancy food—and there's usually a lot of it on a plate. In the last ten to fifteen years, Boston has become home to finer restaurants with recipes from far and wide, but you can still find typical New England foods, and tourists often come to Boston looking for the foods the region is best known for. Here are some of them.

Fried clams and onion rings became famous on the North Shore of Boston, particularly in Gloucester and Ipswich. Vidalia

onions from Georgia make the best onion rings. Clam chowder is a Boston favorite, as are corn chowder and fish chowder. Each summer, Boston holds a Chowderfest to decide which restaurant makes the best.

Brown bread has been around since Pilgrim days. On Saturdays, it was steamed in the wood-burning oven, along with baked beans. It was served warm on Saturday night and cold on Sunday, when Sabbath laws allowed no cooking. Corn bread, johnnycake, cranberry bread, pumpkin bread and Vermont graham bread (made from whole wheat flour) are other New England favorites.

Boston baked beans give the city its nickname, "Beantown." Soak your navy beans in cold water overnight, which will make them large. Then boil them in water for half an hour and rinse. Put salt pork in the bottom of a crock and add the beans, sugar, molasses, dry mustard, white pepper and salt. Preheat your oven to four hundred degrees and bake for four hours. Then let them set for thirty minutes.

Other specialties are Yankee pot roast and New England boiled dinner (corn beef and cabbage). Desserts from the region include apple pie and apple pandowdy (includes molasses), Indian pudding (includes cornmeal and molasses) and Boston cream pie, which isn't really a pie. It's a pudding cake, invented right in Boston's Parker House hotel. There are many others, of course, and you may have a favorite that isn't listed here. The thing about New England cookery is that most of these items have been around for a long time, but they're still popular, and when people come to New England from other parts of the world, they expect to find restaurants and inns that serve these foods—and they do.

WHY DO DONUTS HAVE HOLES IN THEM?

Donuts have been around for a while. Fossils of what look like doughnuts were found in digs of prehistoric American Indian settlements in the Southwest. There were no fresh products there, but they were homemade just the same. So when did today's donuts come on line, and how did they get their holes?

Donut history is mostly legend and half-baked truths, but it seems the Dutch in New Amsterdam (now New York) ate what they called "olykoeks" (oily cakes). Like the Chicago fire, a cow got them going. It seems she kicked over a pot of boiling oil and it fell onto a pastry mix. The result was yummy. Like the pastry mix, it caught on and the creation caught fire. Olykoeks became a staple of old New Amsterdam.

Someone else had a better idea. Elizabeth Gregory loved to bake. She baked cakes and pastries all day long. She had a son, Hanson Crockett Gregory, who was a sea captain. On one of his voyages he brought back spices and gave some to his mother, including nutmeg, cinnamon and lemon rind. Mrs. Gregory made deep-fried cakes for her son and his crew to take back to sea. They lasted a long time on the long voyage. She used the spices he'd given her, but also put nuts in the center where the dough might not cook completely. So they were "dough-nuts."

Now comes the part about the holes. You can pick your favorite version. Here's one: During a terrible storm, Hanson Gregory was eating a donut and needed both hands to control the ship's wheel. So he rammed his donut onto a spoke of the wooden wheel. Later when he finished his donut it didn't have that soggy, nutty center that he used to spit out into the ocean. The spoke on the helm had done that for him. Hanson told his cook, "From now on, make all my donuts without a center."

Another version has an angel appearing to Hanson in a dream holding a tray of delicious donuts with holes in them. The angel told him these would end the suffering of his people. Apparently they did, because everyone loved them and danced in the streets. However, Hanson was burned at the stake for being a witch. You can't please everyone. Hanson Gregory is buried in a cemetery in Snug Harbor, Quincy, south of Boston. Dunkin' Donuts began in Quincy, too, so there's something of a torch transfer in that tale.

Donuts really started to roll during World War I. At that time American soldiers were called "doughboys," so that's a clue right there. On a battlefield near Montiers, France, in August 1817, it had rained for thirty-six consecutive days. The soldiers were drenched and dreary, so some Salvation Army lassies used the ingredients they

had, including a wine bottle for a rolling pin, and made donuts in a soldier's helmet, seven at a time, and baked them on an eighteen-inch stove, cutting out the holes with an artillery shell. They made them in a tent, and soldiers lined up in the rain waiting for them. It was kind of like the take-out lane at a donut shop. They made nine thousand in all, and the tent they were made in became the first twenty-four-hour donut shop.

So donuts were a big hit, and after the war a donut machine was invented that could make them faster to produce. At first, donuts weren't necessarily a breakfast food, but they were popular in New York with the theatre crowd, who ate them as a snack food at intermission. A Russian immigrant named Adolph Levitt owned a bakery in the theatre district and couldn't keep up with the demand, so in 1920 he invented the first donut machine.

Now they were being mass produced and became more popular than ever. By 1934, Levitt was making $25 million a year (even more than the leading donut shop does now) selling his machines. That same year the Chicago World's Fair called donuts "the hit food of the Century of Progress."

In 1937, Krispy Kreme opened its first shop. During World War II, Red Cross women known as Doughnut Dollies passed out hot donuts to the hard-fighting soldiers at the rate of four hundred per minute. Enjoyment of donuts continued to increase. Dunkin' Donuts opened its first store in Quincy in 1950. As coffee became more of a staple in bakeries across the country, the perception of the donut as a breakfast item became more prevalent. The "oily cake" seemed to be on a roll.

But then, in the 1970s, bagels, in the guise of a hardened form of donut, became popular. They were seen as healthier than donuts. Although donuts may have fewer calories than a fully loaded bagel, they do have more saturated fat.

The falloff in donut munching changed again. By the 1990s, Americans were interested in comfort foods, and donuts were certainly that. Today, in the United States alone, over ten billion donuts are made every year. The kind of donut the Red Cross women were handing out with coffee sixty years ago is now called a plain donut, and they've morphed into many sizes, shapes and kinds.

While donuts may still be accompanied by coffee, even that is likely to be more sophisticated, sweeter and more expensive. The donut is still there, but probably with a lot less dunkin'.

WHO PUT THE "FLUFF" IN "FLUFFERNUTTER"?

In the summer of 2006, there was a bit of fluff in the news. It was not the kind of story that usually makes network news shows around the country. It had no bombs, no bullets, nobody sneaking across the border—not even a Hollywood movie star. It was all about another sweet food for kids.

A Massachusetts state senator found out that his third grader had been given a Fluffernutter (peanut butter and marshmallow fluff sandwich) in the school cafeteria, and he hit the roof. This was terrible for nutrition, he said. Why do we let our schools give our kids soda pop, sweets and silly soft stuff like a Fluffernutter? So right away he tried to get peanut butter and marshmallow sandwiches thrown out of school lunchrooms in the Bay State—or at least tossed into the trash.

Trouble was, his attack on Fluffernutters had hit a soft spot. People from all over the state and country had plenty to say— once they got their mouths cleared from sluggish peanut butter and sticky, puffy marshmallow, that is. The one with the most to say was the senator for the district where they make marshmallow fluff: right in Lynn, Massachusetts. Lynn's senator got all puffed up and said she not only approved of them, but even wanted to make Fluffernutters the official state sandwich, ahead of such favorites as BLTs or pastrami on a bulkie.

Well that put the fear of Fluff into the senator with the third grader. He backed down faster than a fireman on a flaming ladder. He said he liked Fluffernutters just as much as the next person and by golly gee, yes, they should be the official sandwich, and he'd vote for that.

So, you see, when you push marshmallows, they push back. Marshmallows are survivors. They won't be flattened or flayed. Even the pharaohs of ancient Egypt tossed them down their throats

like candy. In ancient Rome, they boiled the roots of the marsh mallow plant and fried them in butter. Just the thing for a hot day at the chariot races, since they had no Fenway Franks to munch on.

But Fluff is distinctly American, and so is the marsh mallow, a relative of the hollyhock. They grow in salt marshes along our East Coast and were probably known to the Pilgrims. In the nineteenth century, doctors made a kind of sweet cough drop out of the marsh mallow root that they gave to children as a cough suppressant. They must have understood that a spoonful of sugar helps the medicine go down, but marsh mallow is even better.

Today's kids toast them over campfires, cram them into s'mores and float them in cocoa. Marshmallows have a kind of scrunched-up pillow shape, but they didn't always look like that. When candy makers wanted to make them faster, they put the liquid marshmallow into molds, and that's what gave them the kind of pillbox shape.

Marshmallow fluff is a Somerville, Massachusetts invention. Archibald Query, a person who always asked questions, asked himself why marshmallow couldn't be incredibly spreadable. It could, and was when he made it. Query made batches of it in his kitchen, using sugar to sweeten it, and called it "fluff." He sold it door to door, and he did all right until the First World War started,

and he couldn't get enough sugar to keep him going. A year later when the war ended, he went on to other things and sold his recipe for $500 to two soldiers named Durkee and Mower, who were home from the war.

Durkee and Mower opened a factory in Lynn to make marshmallow fluff. They also sponsored a weekly *Flufferettes* radio show, and from that show came the *Yummy Book* with Fluff recipes, which can still be ordered today for twenty-five cents.

Timing can be very important. The inventor only made a little money from Fluff, while the buyers made a bundle. Now Brigham's has come out with a Fluffernutter ice cream that blends chocolate-covered peanut butter cups, peanut butter ice cream and marshmallow. That sounds even better than eating the Fluff right out of the jar when your mom isn't looking.

Boston: Ice Cream Capital of the World

Americans eat more ice cream by far than people in any other country in the world, and people around Boston eat a good part of that. But where did ice cream come from and how did it get so good?

Ice cream has trickled down from ancient times. You and I might not have identified the earliest prototypes as "ice cream." But we can understand the connection. For example, Alexander the Great (who lived in the second century BC and had his own movie recently) enjoyed eating snow and ice flavored with honey and nectar. That sounds potable. Even King Solomon, whom we've read of in the Old Testament, liked his occasional ice drink—flavored, thank you very much. Then there was Emperor Nero of Rome. Nero had lots of strange habits and desires, and one of them was eating snow he ordered to be brought down from the mountains. His servants brought it to him flavored with fruits and juices. There's still no sign of a Ben & Jerry's or a Dairy Queen in any of that (not even a Nero's Nips flavor), so let's move on.

Over a thousand years later, Marco Polo returned to Italy from the Far East with treasures and secrets of all kinds, most of them

brought back from China. One of these secrets was a recipe for something we would have called sherbet. This was sort of the "missing link" between primitive ice cream and the present. Historians estimate that this sherbet recipe evolved into ice cream sometime in the sixteenth century. In fact, it was called "cream ice." One big fan of cream ice was King Charles I of England, who lived during the seventeenth century.

Like most things European, frozen desserts spread quickly across the continent. They came to the royal court in France when Henry II married Catherine de Medici of Italy and she brought a type of frozen dessert with her. You'll notice that it was the royal folk who appreciated and consumed these novelties and sweet treats. It wasn't until 1660 that ice cream was made available to the general public.

The royalty first trend continued. When the dessert was imported to the United States, it was by the closest thing we had to royalty. Several famous Americans, including George Washington, Thomas Jefferson and Dolley Madison, served it to their guests. Even earlier, in 1700, Governor Bladen of Maryland was recorded as having served it to his guests. Still no Dairy Queens among that royalty.

It was just before the American Revolution, fittingly, that the American populace was brought into the picture. All men were created equal, remember? In 1774, a London caterer named Philip Lenzi announced in a New York newspaper that he would be offering confections for sale, including ice cream. Shortly thereafter, in 1776, the first ice cream parlor in America opened in New York City. It was revolutionary.

Meanwhile, the cream of society was helping itself to lots of helpings of the frozen stuff. President George Washington bought the first ice cream maker and spent approximately $200 for ice cream in the summer of 1790, during the third year of his presidency. I guess you could say he earned it. Inventory records of Mount Vernon taken after Washington's death revealed "two pewter ice cream pots," so the servants must have been making tubs of it.

Not to be outdone, President Thomas Jefferson was said to have a favorite eighteen-step recipe for an ice cream delicacy that

resembled a modern-day baked Alaska. The recipe is now in the Library of Congress. And in 1812, Dolley Madison, the wife of our fourth president, served a magnificent strawberry ice cream creation at President Madison's second inaugural banquet at the White House.

That accounts for presidents one, two and four. Nothing is said about second President John Adams's pursuit of "Abigail's apple nougat" or even "John's granite crunch." But we'll see later that when ice cream came to Quincy, everything went down smoothly.

Manufacturing ice cream soon became an industry in America. A Baltimore milk dealer named Jacob Fussell started it in 1851. Fussell was just in time for the Industrial Revolution, and ice cream was ready to take off like a rocket. Like other American industries, ice cream production increased because of technological innovations, including steam power, mechanical refrigeration, the homogenizer, electric power and motors, packing machines and new freezing processes and equipment. In addition, motorized delivery vehicles dramatically changed the industry. Due to ongoing technological advances, today's total frozen dairy annual production in the United States is more than 1.6 billion gallons.

By the last third of the nineteenth century, ice cream was relatively easy to get in all parts of the country, but it was about to become more so. In 1874, the American soda fountain shop and the profession of the soda jerk emerged with the invention of the ice cream soda. The job title probably didn't attract too many people, but the side benefits probably did.

If you think some folks are unduly interested in what others are doing now, you're lucky you didn't live then. Churches criticized drugstores and soda fountains and the people who went there for eating "sinfully" rich ice cream sodas on Sundays. That may have led to the phrase "sinfully good," but ice cream vendors were little devils in those days. They just left out the carbonated water and invented the ice cream "Sunday" in the late 1890s. The use of that word was a little too provocative, so the name was eventually changed to "sundae" to remove any connection with the Sabbath.

The ice cream cone became popular during the St. Louis World's Fair of 1904. Charles E. Menches gets most of the ink, but there

may have been at least fifty ice cream cone stands at that fair, and several people may have come up with the idea. Menches had been selling ice cream in cups. When he ran out of cups he dashed over to the Belgian waffle booth next door and made an arrangement for the vendor to make waffle cones. There was no waffling on this deal. Waffle man made the cones and Menches just filled each of them with two scoops of ice cream. Voila—the cone. In fact, voila, the waffle cone.

During World War II, it was important to the military to keep up the morale of its troops. Each branch of the military tried to outdo the others. One thing that showed "American know-how" was being able to serve ice cream anywhere in the world, even on islands with steamy jungles. In 1945, the first floating ice cream parlor was built for sailors in the Pacific.

Servicemen were doing better than their families at home ice cream–wise, because dairy products were rationed in the United States. When the war ended and rationing was lifted, America went on an ice cream binge, consuming over twenty quarts per person during the first postwar year.

Better and cheaper means of refrigeration led to the spread of ice cream's popularity all over the world in the twentieth century. Soon there were ice cream stores everywhere and lots of new flavors, too.

Another development was the introduction of soft ice cream. Former prime minister of Great Britain, Margaret Thatcher, was a member of a chemical research team in England that found a cheap way of putting in more air and smaller amounts of ingredients to make lighter soft ice cream. Sort of an offshoot of inflation? Could Dairy Queen be far behind?

DQ was actually ahead of that. The Illinois-based company made its first sale in 1938. By the time of Pearl Harbor in 1941, there were fewer than ten stores, but the company grew quickly during the 1950s and beyond, to nearly six thousand outlets today.

Ice cream began to be prepackaged and sold through supermarkets. As it did, traditional ice cream parlors and soda fountains melted away. Now, like Brigadoon, they've come back. Stores like Ben & Jerry's, Häagen-Dazs and others making thicker, higher-quality ice creams have become popular.

People in the Boston area love to eat ice cream—lots of it. We are really the ice cream capital of the world. Just south of Boston in Quincy, a man named Howard Johnson bought an old drugstore on Beals Street in Wollaston in 1925. He hired a German immigrant to teach him the secrets of making ice cream.

Howard Johnson offered more than just the traditional vanilla and chocolate. His stores became known for offering twenty-eight flavors and also for the orange roof on its restaurants, which grew to include hotels in what was once the largest chain of restaurants and hotels in the United States.

Brigham's began in nearby Newton over eighty years ago. New England is also home to such ice cream giants as Friendly's, Ben & Jerry's, Steve's, Herrell's and J.P. Licks. Ice cream is probably so popular around Boston because there are so many shops that make their own. Early each summer, the Scooper Bowl ice cream festival is held at Government Center opposite Boston's city hall.

It's still sold at farm stands in this area, and as everyone knows, homemade is best. Nero never knew that.

Part Five

PORTENTOUS PLACES

THE CITY SKYLINE: A ROCK PILE OF CHOICES

If you've ever traveled to the West, where you can look at vast rock formations, you may have noticed that among the cliffs, which may have been made of sandstone, there are often layers or shafts of another, harder rock—perhaps granite. These layers and shafts remain because they are harder to wear down. They have staying power.

Some buildings are like that, too. The older ones have usually survived fires or floods, perhaps earthquakes and certainly the wrecking ball. The city of Boston is a lot like that, as you will see.

As we approach the city from the water, or look across from the airport, notice the skyline of tall buildings that looms before you. The buildings are of different heights, made of different materials and have differing designs. Some are quite a bit older than the others. As you come ashore and walk through the "caverns" of buildings, you'll see some older buildings that are not tall enough to be seen from the water. These, too, are survivors. And why are they still here, while those around them have all fallen and been forgotten? Mostly, they've been spared because someone, long ago, thought they were still useful. Or someone understood that they were important to history.

Boston is luckier than most cities in this way. If you went to New York, Los Angeles or Chicago, for example, you'd look long and hard for older buildings and historic sites. If you found them, they might be located away from the downtowns, where the land is not so expensive and in demand.

In Boston you'll find old, historic buildings right in the business district. The Old State House stands at one of the busiest intersections in the city. The tall buildings around it make it look like a dwarf among giants. You'll also find older buildings in residential areas and surrounded by houses. That's true in the North End—the Old North Church and the Paul Revere House, for example. They stand among stone houses, some of which sell at the high end of the city real estate market.

Perhaps the best example is the Faneuil Hall–Quincy Market complex. It occupies what might be the best real estate in Boston. It's old, but it's been updated. You can still see how these buildings were used when they were new, but they're now used for modern purposes. And so many visitors go there from around the world that Boston rivals Disney World as a tourist attraction.

We also have the (new) State House with its gold dome on top of Beacon Hill. It was built in 1798 as the state capitol, and is still used as the state capitol. Its spacious interior, with its granite and wide marble stairways, tells you that it's an important place. That's what Charles Bulfinch intended when he designed it over two hundred years ago. At that time, it was the highest building in town and dominated the skyline. You can still pick it out from a boat. But like a shaft of granite, it's now surrounded by newer buildings, some of them less interesting but useful. Boston is like that. It's famous for its blend of old and new. We can thank historic preservation for keeping many older structures and giving them useful jobs to do.

FANEUIL HALL—CRADLE OF LIBERTY—IS REALLY ROCKIN'!

In the early 1700s, Boston was the largest town in America. A new dock had been built that stretched so far out into the harbor that it was called Long Wharf. But so far no market building existed, and of course there were no supermarkets or convenience stores like we have today.

How, then, did people get the things they needed? One way was to go down to Long Wharf when a ship came in and buy things right off the ship. Another was to wait for a farmer to bring his

goods into town on his wagon and make a deal with him. That meant you could haggle over the price of things and maybe make a good bargain—or perhaps not. You might get cheated. Some people thought a market building was needed. The town could run it and make sure things were clean, prices were fair and the market was open at regular times. City dwellers would also be able to get things when they needed them, whether a ship or a farmer happened to be going by or not. Others didn't like the idea of the government running anything, as governments liked to put a sales tax on everything. Finally the town voted to build a market, but without much enthusiasm. For two years nothing was done. Then they voted again and this time decided not to build it. Things were at an impasse.

Then along came Peter Faneuil. Peter had inherited a lot of money but hadn't done much with it except to have a lot of parties. One night he was having a party and he ran out of food and wine. He complained that there wasn't any market where he could get more party supplies. (He probably could have built an all-night convenience store if he had known what that was.)

The fact that he had run out of wine suggests that his guests drank quite a lot of it, and that Peter may have had his share before that happened. He bragged to his friends that he would even pay for a market if the town would build one. The next day, without telling Faneuil, his friends told everyone what he had said. They circulated a petition to have the town build a market and take up Faneuil's offer to pay for it. The petition got 147 signatures.

Some people were as cynical then as many people are now, and many just could not believe anyone would build a market just to help the town. They thought it was some kind of trick. But because of the petition with all the signatures, the town had to have a vote on whether to accept Peter's gift. A no-cost market seemed like a no-brainer, but it wasn't. The vote was 367 in favor and 360 against accepting his gift. The market was just barely accepted.

The hall was finished in 1742, but Peter Faneuil died only six months later. The hall was not a success as a market. It had trouble renting space. In fact, it was closed a number of times because nobody was interested in using it. While it wasn't an immediate

success as a market, the space was used more and more to hold meetings, as it was the only space big enough to hold them. Finally, when a fire destroyed everything except the walls, people realized they had nearly lost their only meeting space, so they chipped in money to have it rebuilt. Politically active residents of Boston gave lukewarm support to a market, but they had to have a meeting hall, especially in the middle of the eighteenth century.

Before the Revolution, Faneuil Hall became known as the "Cradle of Liberty" because Bostonians met there and protested things the king's government was doing, like taxing them without their consent, making people take soldiers into their houses to live there and closing down the port of Boston. Once the Revolution began in 1775, there were no more meetings. Instead, British troops used Faneuil Hall as a barracks.

That left it a mess, of course. Once the British cleared out of town, the building had to be renovated. It needed to be redesigned and it needed to be bigger. In 1805, the famous Boston architect Charles Bulfinch remodeled the building. He added an extra one and a half floors plus a cellar, and he made the building wider. The grasshopper weathervane he placed on top has become the most famous one in the world.

If you go into Faneuil Hall today you'll find lots of tourists. You'll also find a market on the first floor and in the cellar. The second floor has a huge meeting room with paintings on the walls and is often shown on television during political meetings. The top floor is occupied by the oldest military company in America and has a great military museum.

Unfortunately, during the Revolution, Faneuil's family sided with the king and when the British left Boston, the Faneuils also got out of town fast. Like most Tories, they fled to Canada. A mob destroyed Peter's portrait in Faneuil Hall and gave the Faneuil home to the lieutenant governor. But they couldn't destroy Faneuil's greatest accomplishment. His name remains famous for the hall he paid for. It's still used, even though we now have convenience stores as well.

QUINCY MARKET: WHERE THE WORLD MEETS BOSTON

Quincy Market or Faneuil Hall Marketplace are popular names for Boston's favorite tourist attraction. People from all over the world come there to shop, eat, have fun and become "part of Boston." You may have been there. If not, you should visit.

And what will you see? First of all, four magnificent buildings that have been saved since the early 1800s. Faneuil Hall, with its golden grasshopper weathervane, is the oldest (1742) and most historic. Just across from Faneuil Hall lie three long, granite buildings, which together make up Quincy Market. It's named for Boston's second mayor, Josiah Quincy, whose idea it was to build

it. At that time, the town again needed an indoor market and he tried to get the city council to have one built. They thought it was a crazy idea, but he told them that the money they spent would be repaid by merchants who would rent space in the buildings. In the end he got them to vote—not only for three buildings, but also for new docks and new streets.

We know Quincy Market brings people to it now. But it also brought people to watch while it was being built—just the way people came to watch the making of the Big Dig. (We now know that they didn't watch closely enough.)

To make room for the market, builders had to move a creek that ran through there. They moved it four hundred feet so it would empty into the harbor instead of the marketplace. No one had ever seen a creek being moved before, so they came to watch and thought it was awesome. They loved to watch huge blocks of granite being unloaded off wagons and boats and lowered into place by ropes and pulleys. Cranes and trucks weren't used, simply because they didn't have any then.

The market opened in 1826 and thousands of Bostonians came every day. Guess what for? To do their shopping, eat lunch and meet their friends. In the twenty-first century, people once again go there for shopping, having lunch and meeting friends !

The whole thing cost a mere $1.1 million and (as the mayor predicted) it was paid back by rentals and sales in a year and cost the taxpayers not one red cent.

As time went on, changes were made to the buildings and they became shabby and run-down. The place became a disaster. Merchants moved out and the buildings became overrun with rats. In fact, the whole city got run-down and by the middle of the twentieth century it all had to be renewed. A lot of it is done. Quincy Market got a first-class makeover and was re-opened in 1976. Some things stay the same. Some don't. One of the 1826 tenants was an eating place called Durgin-Park. It served meals using food that had been brought to the market the same day. The people who worked in the market and the sailors off the ships ate there. Ordinary people liked to join them at the long, family-style tables. It made them feel like part of the action. Durgin-Park is still there. You still sit at long

tables with strangers eating plain food. But today the people at the table with you may be from other countries—or at least from the suburbs. They think they're having a "Boston experience." You may want to try to have one too.

BUNKER HILL GRANITE

From higher elevations in Greater Boston you can easily see the Boston skyline and, just north of Boston, the Bunker Hill Monument in Charlestown. Most who can see the monument on the horizon know the story of the June 17, 1775 battle, but fewer probably know how difficult it was to get the monument built and how a search for the best stone led to a South Shore quarry.

Twenty-two years after the battle, a simple wooden memorial had been raised on Breed's Hill, where the actual battle was fought, but something grander and more permanent seemed to be required. In 1822, William Tickner, who lived across the street from the recently built State House on Beacon Hill, suggested a stone memorial, and Thomas Handasyd Perkins, one of the prime movers in the Boston of his day, invited a few friends over to his house for breakfast to discuss the matter. Perkins's friends included some of the most influential people in Boston.

They formed a group called the Bunker Hill Monument Association (BHMA) and they held the first public meeting in 1823. Each member subscribed $5 and the main work—raising money—began. It started auspiciously with an individual contribution of $10,000, which must have made everyone hopeful. But, in fact, money would not come in gushes, but only in trickles. Two years later, the group had been able to buy about fifteen acres at the top of the hill. All of the landowners had agreed to sell their pieces of land at the price appraisers set, and agreed that they would pay a penalty of $500 if they backed out.

One landowner could not be accused of being patriotic, however. When he was approached, he told the committee to go to everyone else and then come back to him. After the others had sold their land, he was again approached. Now he had them over a barrel. His

was the last piece of land and now he wanted $5,000 for it. Rather than hold out and delay the project, they paid his price.

It didn't speed things up, though. Now the committee had to choose a design. They held a contest, and Solomon Willard's obelisk design was chosen. It would stand 221 feet tall and would be the first public obelisk in the United States. It would have 294 spiral granite steps inside, leading to an observation platform at the top.

A ceremony to lay the cornerstone was held on the fiftieth anniversary of the battle: June 17, 1825. A crowd of 100,000 included 190 men who had fought there. The Marquis de Lafayette, the French nobleman who had fought alongside Washington in the Revolution, was asked to lay the stone while famed orator Daniel Webster served as master of ceremonies and delivered the major speech.

Even as the cornerstone was put in place, the committee didn't have enough money to complete the project. Some wanted the Commonwealth of Massachusetts to pay for it, but this didn't happen. Then, as now, the governor and legislature couldn't agree on things. The governor proposed that the state pay for it, but the legislature wouldn't go along. Construction was often halted as funds dried up.

Meanwhile, the designer, Solomon Willard, looked all over New England for suitable stone and finally found it in the granite quarries of Quincy. He also invented the machinery to cut and handle the slabs of stone taken from what became known as the Bunker Hill Quarry. It was excellent building stone, but there was a problem: the quarry was twelve miles from Charlestown.

The stone would have to be hauled by water, but the Neponset River was three miles away. The solution was to use a railroad. There was no railroad, but civil engineer Gridley Bryant built one, and did it quickly. William Gardner laid the stonework on which the tracks rested. This was the first railroad in the United States. On the morning of October 7, 1826, the first horse-drawn cars moved over the tracks.

Few historic events occur in a vacuum, and this, too, had ramifications. Quincy became a center of the granite industry. The railroad took the stone to the water and it was brought to places

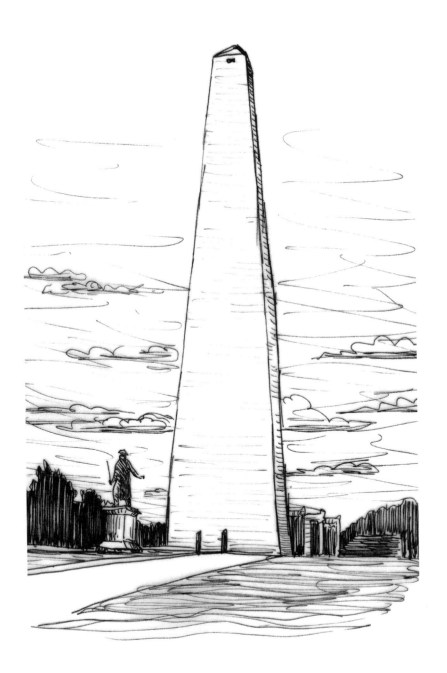

along the coast as far south as Louisiana. Immigrants from Finland, Sweden, Italy and elsewhere swelled the city's population as they came to work in the quarries and related industries. Closer to home, the granite was used for Boston's Custom House and Scituate's Minot Light.

At one time there were more than twenty active quarries in Quincy. A decline followed World War II, and the last of them closed in the 1960s. The deep, unused quarries filled with rainwater and became a dangerous attraction for young people who used them for diving. A number of people were killed. Several quarries have been filled with dirt from the Big Dig and covered by a golf course. The Metropolitan District Commission now owns twenty-two acres, with a few quarries, and there are hiking trails too. Portions of the 1826 granite railway can still be seen.

The railway was added to the National Register of Historic Places in 1973. A plaque from 1926, along with an original switch, a piece of track and a section of the granite railway, can be found in the gardens on top of the Expressway at East Milton Square, about where the railway went through Milton on its way to the Neponset River.

The granite did eventually find its way along those tracks, down that river and up the coast to Breed's Hill, where it became the stone of the Bunker Hill Monument. But the association was forced to sell off much of that land it bought in order to raise funds. They saved only the summit. In addition, schoolchildren sent pennies and adults paid $5 to join the BHMA. However, women did the best, raising $30,000, most of it via the Ladies' Fair at Quincy Market, where they sold all kinds of goods to raise funds for the monument.

After eighteen years, the monument was completed. It was dedicated on June 17, 1843, with another huge celebration. Daniel Webster again gave the oration and President Tyler took part in the three-mile march from the State House. Many dignitaries attended, but not former President John Quincy Adams, who despised both Webster and Tyler, believing that neither was a man of character.

Annual celebrations began. The next big Bunker Hill Day celebration came on the 100th anniversary. It was the last run by the BHMA. The men who ran it were mostly Boston Brahmans,

and Charlestown was by then mostly Irish. Celebrations that had been marked by concerts, speeches, parades and yacht races instead began to feature fireworks, burlesque performances and open houses, making it a holiday, as one paper said, "that strongly commingled, patriotism and punch."

The Bunker Hill Monument Association maintained the monument and grounds until 1919, when it was turned over to the Commonwealth of Massachusetts. In 1976, the monument was transferred to the National Park Service and became a unit of Boston National Historical Park. The city of Boston observes Bunker Hill Day as a legal holiday, but the monument itself is made of solid South Shore granite.

THE SKINNY HOUSE AND THE NARROW MIND

Not far from the Old North Church and the site of the great molasses flood is a curious house in Boston's North End. Located at 44 Hull Street, right across from Copp's Hill Burying Ground, this home is the tiniest in the city. Some houses may be skinny, but this one is anorexic. It's nine and a half feet wide along the sidewalk and only three feet wide in back. It's also thirty feet deep. So it's shaped like a wedge of pie. Boston real estate is expensive, but why would anyone build a house this small? Well, there's a story behind it, whether true or not.

Joseph Eustis inherited a small piece of land, but his older brother inherited a much larger piece. While Joseph was away, his brother built a large house using most of the land. Only a thin strip was left for Joseph. It was so tiny that the older brother thought Joseph would just lose interest and forget about it, and then he'd have the whole parcel to himself. But Joseph Eustis had something else in mind. Joseph built his skinny house, but he built it four stories high, and since it was between his brother's house and the ocean, it blocked the magnificent view from the larger house!

The four stories are connected by a steep, narrow staircase and the ceilings are low—only six feet, four inches on the top floor. Today, the fourth floor is the master bedroom. It holds a queen-

sized bed since that's the biggest that would fit. Even that bed was too big to bring up the stairs, so movers had to saw it in half, hoist it through the back window and then reassemble it. All that happened in 1659, and the bed is still up there. It has to be. It's stuck.

151-431-0617

About the Author

This is author Ted Clarke's seventh book. He's a historian in the town of Weymouth, having served as chairman of its Historical Commission and author of a book on the town's history. He has also produced four videos on historical subjects, as well as weekly newspaper articles on local and regional history. He has also written a book on inventions, a biography of Thomas A. Watson of telephone fame and is completing books on John Quincy Adams and Johnny Appleseed.

His avocation is figure skating. He has served as a national judge and as president of the Skating Club of Boston, ran the U.S. Championships in Boston and served as the first vice-president of U.S. Figure Skating. He has written three books on skating and served for twenty-five years as co-editor of a magazine on the sport.

Visit us at
www.historypress.net